Harry Hennings · Minolta Maxxum · Dynax 3xi and SPxi

# MINOLTA

## International

## U.S.A.

 **HOVE FOTO BOOKS**       Harry Hennings

# In U.S.A.

the Minolta Dynax 3xi and SPxi are known as the

## Maxxum 3xi and SPxi

All text, illustrations and data apply to any one of the above cameras

First English Edition February 1992
Published by Hove Foto Books
34 Church Road, Hove, Sussex BN3 2GJ

English Translation: Petra Kopp
Technical Editor: Colin Leftley
Minolta Technical Advice: Neil Whitford
Production Editor: Georgina Fuller
Typesetting & Layout: Annida's Written Page, Sussex BN43 5HH
Printed in Great Britain by The Bath Press, Avon

**British Library Cataloguing-in-Publication Data.
A catalogue record for this book is available from the British
Library.**

ISBN 0-906447-96-8

UK Distribution:

Newpro (UK) Ltd.
Old Sawmills Road
Faringdon, Oxon
SN7 7DS

# Contents

Fast framing without changing your shooting position is possible with the Minolta Power Zoom on the 3xi or SPxi. Photo: Rudolf Majonica

# A good introduction to SLR photography

The Minolta Maxxum/Dynax camera range represents the most up-to-date SLR technology for all photographic requirements. With the 3xi and SPxi, Minolta offers an easy and inexpensive way into the world of autofocus SLR photography. Both cameras are extremely compact in design, are comfortable to handle and only a few switches and buttons are needed to operate them. The software used by the computer control system has expert knowledge which ensures a higher number of technically-perfect shots. This also means that fewer shots are lost because the photographer is still busy setting the camera long after the event. The xi series cameras switch on automatically as soon as they are at the eye. At the same time they focus on the subject they are aimed at, select a suitable zoom setting automatically and control the exposure. All settings are continuously adjusted to allow for any changes in the shooting situation.

The two Minolta xi beginner's cameras are very similar in their handling and technology and differ only slightly in the features on offer. Where the Minolta 3xi has an integral flash unit, the slightly cheaper SPxi offers spot metering, but both cameras are compatible with the entire Minolta AF accessory range. Unlike other Maxxum/Dynax cameras, however, they don't allow the use of expansion cards to let you re-programme their automatic functions.

Both cameras are designed to offer a carefree start to SLR photography. But despite their high degree of automation, which frees photographers of all technical worries and allows them to concentrate fully on their subjects, manual intervention is possible at any time. This allows photographers to realize their own creative ideas.

The first part of this book covers the basics of the camera's handling and the technology at its root. Building on this, a more practice-oriented part follows giving hints and tips on how this technology is best used to achieve excellent photographs, simply.

The reasons for taking photographs are as varied as our different personalities. But one thing is common to us all - the desire to wrest a moment from life and preserve it forever in a picture. The

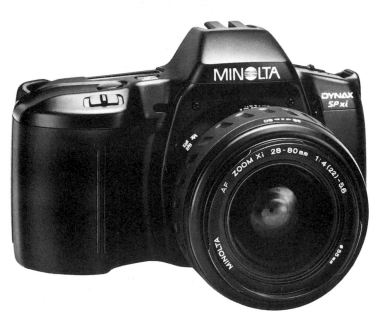

Minolta SPxi with additional spot metering.

demands imposed on an ideal camera are as different as the temperaments of photographers, their motivation, and how their photographs will be used later. Roughly speaking, photographers can be divided into two groups. Some enjoy searching for pictures and set out on a photographic hunt, always on the look out for anything new, surprising or unusual.

Those in the other group already carry their pictures with them in their heads and always keep on the look out for an opportunity to turn their ideas into photographs. In order to use all the different creative possibilities, they devote a great deal of time to photographic theory, immerse themselves in photographic technology, and work towards every single picture step by step. For many the hunt itself is the enjoyment. It is not the result that matters most to them, but the satisfaction they draw from the pursuit of photography itself.

10

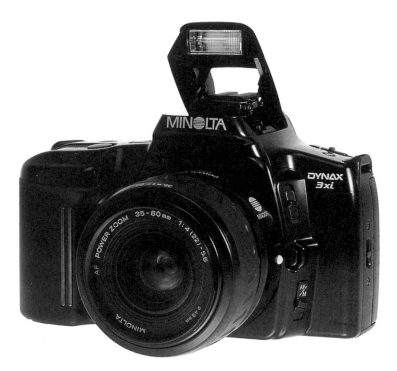

Minolta 3xi with integral flash unit.

The first, much larger group of photographers are quite different. To them, photographic technology and its complicated rules are just a necessary evil on the way to good photographs. They want to be able to capture true-to-life scenes, at the touch of a button. They want to freeze the event, the decisive moment, and preserve it for ever. They want to be spared as much as possible the calculation of the effects of shutter speed, aperture, exposure, film speed, lens speed or focal length. What is important to them is that the shot is razor-sharp, correctly exposed and has attractive colours that are as close as possible to what they saw. They want to take carefree photographs without worrying about the complications of photographic technology.

Happily, these desires can now largely be fulfilled by cameras such as the 3xi and SPxi, thanks to constantly improving photographic technology and advances in cameras, lenses and films.

Everybody has to decide for themselves which of the two cameras is right for them, after analysing their photographic objectives. The SPxi in particularly can be recommended as a second camera body. Not every camera needs an integral flash unit. The integral flash unit of the 3xi can't be used with all Minolta AF and xi lenses anyway, because some have such a large diameter that they get in the way of the flash tube. Also, if you mostly work in the close-up range, you can do without the integral flash unit and use the Minolta Macro Flash 1200AF Set N instead.

Every year, professional and amateur photographers document the large and small things of everyday life throughout the world in several thousand millions of photographs. Pictures from space, from science and technology, of current cultural or political events, as well as from our private lives bear lasting witness to our times. Every day an enormous flood of pictures in the media provides us with powerful impressions of what is happening in the world. This multitude of impressive pictures not only informs us about what is going on, but also sets standards by which we all measure the quality of our own photographs. Pictures are part of life, and constantly dealing with them has become natural. Just as natural is the demand for cameras which automatically provide technically perfect photographs that fulfil the quality standards we see documented daily in newspapers and magazines. The Minolta 3xi and SPxi are cameras which really fulfil such requirements. Loading a film, aiming at the subject and releasing the shutter are basically the only things the photographer has to do. These two cameras, as light as they are compact, guarantee technically sound shots with optimum exposure and sharpness. They also offer great handling. On the basis of subject analysis and with the help of the expert knowledge stored in the computer, their fuzzy logic control system also takes into account creative considerations like the automatic selection of zoom setting, aperture and shutter speed. Despite such automation, however, both are fully-fledged SLR cameras, able to meet all individual creative desires and integrate with the world's most comprehensive accessory range for autofocus photography. For despite all the automatic control systems that make things easier for us, it is still the photographer who takes the shot. In the final analysis, it's still us that determines whether a shot turns out just a souvenir, or an attractive, expressive picture.

# Why an SLR camera?

Nowadays you can take good pictures automatically with increasingly well-equipped compact cameras. Here, you can also enjoy the benefits of variable focal lengths plus automatic exposure programs, motorized film winding, and autofocus. Integral flash units have by now become standard. So why would you need such a sophisticated SLR camera as the Minolta 3xi?

Until now, the main arguments in favour of zoom lens compact cameras were their easy handling, compact design, low weight and relatively low price. The Minolta 3xi is far superior to comparable compact zoom cameras on all those counts. Although it is an SLR camera, with the widest choice of interchangeable AF lenses in the

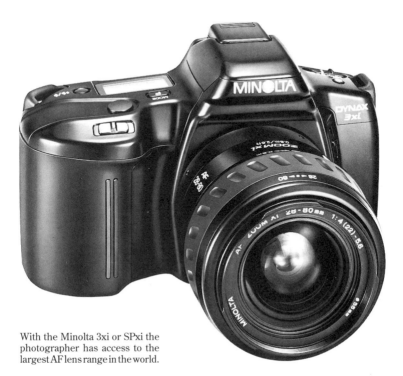

With the Minolta 3xi or SPxi the photographer has access to the largest AF lens range in the world.

Thanks to the Minolta eye-start system the camera is activated as soon as it is at the eye. The autofocus immediately focuses on the subject in the focus frame - snapshots are no longer lost.

world, its compact, handy design makes it hardly larger than the cameras with integral zoom. When it was introduced, the Minolta 3xi was the smallest autofocus SLR camera with integral flash unit in the world.

The 3xi and SPxi have one of the most advanced AF systems. Their expert autofocus recognizes whether a subject in the viewfinder is moving or still, and automatically selects the appropriate AF mode. When setting the distance, the camera's computer takes into account the speed of the subject and adjusts the focus after the shutter release button has been pressed right up until the actual moment of exposure. Based on the speed registered, the continuous autofocus automatically calculates the path the subject takes in the time lapsed between pressing the shutter release and the opening of the shutter, continuously adjusting the distance setting as required. The cameras' exposure metering system and control program, too, are far more complex than those of comparable zoom compact cameras. The SLRs' motor allows faster continuous shooting - not to mention the eye-start automation function. Image size lock and automatic zoom selection are nowadays also offered by cameras with an integral zoom lens.

But there are two features of SLR cameras which make a decisive difference when they are compared to all other systems. That's the ability to use interchangeable lenses, and the opportunity to see the composition through the interchangeable lens. This means that the photographer will see the composition in exactly the same way as it will be projected onto the film through the open shutter after the mirror has flipped up. The photographer can select the optimum focal length at any time, depending on the shooting position and the desired cropping. You can decide whether you want to use fast fixed focal length lenses, or whether a variable focal length zoom will be more suitable for your purposes. The interchangeable lenses available for the 3xi and SPxi range from super wide-angles and specialist close-up lenses right through to the super telephoto range. But the cameras' great technical advantage only becomes clear in combination with the new xi zoom lenses that offer automatic focal length control.

The ability to see the viewfinder image through the optical system that also measures the exposure - through the lens - provides more confident picture composition. The parallax problems of cameras which use separate optical systems for viewfinder

and exposure, does not exist with SLR cameras. So So the viewfinder image always corresponds to the angle of view of the lens used thanks to the clever positioning of a mirror inside the camera body. This directs the image of the subject produced by the lens directly into the viewfinder. The mirror flips up during the actual exposure, and the shutter opens so that the light falls directly onto the film. Although the viewfinder is closed at this moment, immediately after the exposure has been made, the mirror flips back down, opening the viewfinder.

The advantages of this system are obvious. As the exposed and viewfinder image are identical, the optical system of the viewfinder does not have to be adjusted to a different focal length when the lens is changed. Parallax, or the deviation in the optical axis between separate viewfinder and lens system, causes problems at short shooting distances. Here the viewfinder image is slightly different from the one that reaches the film. As SLR cameras use only one optical system, this problem doesn't arise. SLR cameras therefore work in a fashion termed 'WYSIWYG' in computer jargon (What You See Is What You Get). What is visible in the viewfinder will also end up on the film - with one small proviso. The viewfinders of the 3xi and SPxi show approximately 90% of the actual image area, roughly corresponding to the image area of a framed slide. The actual image will not be fully represented either, as the camera always shows the scene with the iris diaphragm open. The smaller the aperture selected by the camera greater the difference between viewfinder and exposed images will be. Small apertures increase the depth of field. This means that the sharp area extending either side of the focused distance is larger the more the lens is stopped down. This change cannot be made visible in the viewfinder of the 3xi and SPxi as neither camera has a depth of field preview button.

# Getting started

The Minolta 3xi and SPxi are designed so that everybody can easily take photographs right from the start, without any lengthy preparation. But you do have to make a few necessary preparations before the first shot. The power supply has to be loaded, the lens attached, the protective plastic cover removed from the shutter, and the neckstrap fitted for security and comfort. It's always advisable to also familiarize yourself with the different operating controls by doing a few trial runs. In the following I will first describe the operating controls both cameras have in common, then the 'small differences'.

## Attaching the neckstrap

The first thing you should do is attach the neckstrap supplied with the camera - remember safety first! To do this, the Minolta 3xi and SPxi both have two eyelets, at the top right and left of the camera. The ends of the neckstrap are pushed through, then threaded through the rubber clamps on the neckstrap, before being pulled through the buckles along the length of the strap. Although attaching the neckstrap should not present any problems, you should do

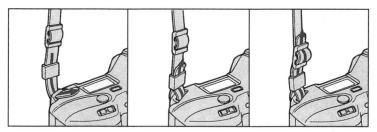

This is how the neckstrap should be fastened to the camera.

it carefully. It would be a shame to drop such an expensive camera just because you were negligent and the neckstrap came undone. The viewfinder eyepiece cap is also attached to the neckstrap and this is important for long tripod exposures, or for self-timer shots.

It blocks off the viewfinder eyepiece to prevent the exposure metering system being adversely affected by light entering through the viewfinder. This cap is securely attached to the neckstrap. It also doubles as storage for the accessory shoe cap when a flash unit is mounted on the camera. Otherwise the accessory shoe cap should always stay on the camera to protect the contacts against dirt and dust.

## Battery loading

The power supply must, of course, be fitted in order for the camera to function at all. Without power nothing will work on today's modern cameras. The Minolta 3xi and SPxi both use a 6-volt 2CR5 type lithium battery as their power source. Lithium batteries are now the standard power source for cameras worldwide, and Minolta uses this battery type for all Maxxum/Dynax models. This has the advantage that somebody with two such cameras only needs to keep one battery in reserve should one camera fail. After all, it is unlikely that both batteries will become flat at the same time.

The lithium cell is accommodated in the handgrip on the right-hand side of the camera. The camera should be switched off when loading the batteries and this is done by pushing the main switch to the **LOCK** position. Then the battery cover release on the underside of the camera needs to be pushed inwards to open the lid. The lithium cell is shaped to correspond to the shape of the battery chamber, so it's hardly possible to insert it incorrectly. You only have to make sure that the battery poles are pointing towards the top of the camera. This is also indicated inside the battery compartment. If the battery is inserted the wrong way around, the data panel will remain blank and all camera functions are locked. Once the battery has been inserted, the lid is simply closed and automatically locked.

Lithium batteries are now commonplace in SLR cameras. They are better suited to cameras than alkaline-manganese batteries because of their high resilience, their relatively great tolerance to changes in temperature and their long lifespan. A further advantage is that they can be stored for longer periods of time because their self-discharge is extremely low. Lithium batteries can retain

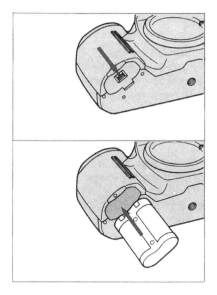

To load the battery, you need to set the main switch to **LOCK** and release the battery cover. Insert the battery according to the marks inside the battery chamber, with its poles pointing towards the top of the camera. Then close the battery cover, pressing it down until it snaps shut.

the power stored in them for up to five years. As they have to be changed less frequently because of their greater capacity, they are also less damaging to the environment. But when changing batteries you should always remember that spent lithium blocks do not belong with household rubbish, they have to be disposed of separately. It's best to give them to your photographic dealer who will ensure that they are disposed of safely.

You must never try to recharge spent batteries. Also, they must not be thrown in a fire, be exposed to very high temperatures, or short-circuited, otherwise they could explode. They must not be dismantled, either, as this would release poisonous chemicals which damage the environment and could cause burns or allergies. Always follow the manufacturers' instructions and remember that batteries do not belong in children's hands.

According to Minolta's data, a fresh lithium battery will, under normal temperatures, provide sufficient power to expose approximately 65 rolls of 24-exposure film with the SPxi. According to the manufacturer's data, the 3xi will only manage about 60 films, provided the integral flash unit isn't used. But depending on how frequently the flash unit is used, the higher amount of power

required will reduce this figure. You should also remember that the first battery won't last the minimum figure indicated, as you will use a substantial proportion of power trying out all the different functions.

The charging state of the battery will be indicated by the battery symbol on the data panels of both cameras when they are switched on. At full capacity, the full battery symbol will light up for four seconds. As the battery charge decreases, the low battery symbol will let you know that you should have a fresh battery ready. However, the camera will still work fully, and the symbol disappears after approximately four seconds. If the battery charge is very weak, on the other hand, this symbol will flash continuously and will not disappear during operation. The camera will still function correctly, but the battery should be replaced straight away. The remaining charge is no longer sufficient for correct camera functioning if all other indicators disappear and only the battery symbol and the additional **bAtt** indicator flash on the data panel. This indicator also appears when the camera is switched off and the main switch is set to **LOCK**. The battery must be changed immediately!

Although lithium batteries perform very well even in low temperatures, the camera should be kept warm under the coat or jacket in breaks between shots during longer periods of sub-zero use. It is also advisable to keep a fresh replacement battery in a warm interior pocket, in case the power of the camera battery should fail suddenly. Cold batteries can recover once again in normal temperatures, so don't throw them away.

*In the Seychelles you won't just find beaches and sea but also a variety of other subjects. The most spectacular subject isn't always the most worthwhile.*

## Attaching the lens

When no lens is attached to the camera, the camera bayonet is protected against dirt, dust and mechanical damage by a special cap. This cap can be removed by turning it anti-clockwise and the same applies to the cap on the bayonet of the lens. When attaching the lens to the camera, the main switch should be set to **LOCK**. The red index marks on camera and lens bayonet first have to be aligned so that the lens can be inserted into the camera's lens mount. The lens is locked in the mount by a slight turn clockwise and a clearly audible click confirms that the lens has engaged and locked. To disengage the lens, you need to press the lens release to the right of the camera bayonet, turn the lens anti-clockwise as far as it will go, and then lift it out carefully.

The lens moves easily in the bayonet. You should never use force, as the camera and lens connections could be damaged if the lens is jammed.

If the lens has been attached incorrectly, two small lines appear instead of the aperture display on the data panel when the camera is switched on. These are also visible if there is no lens on the camera, or if the AZ/MZ switch of an xi lens is in the **MZ** position.

When changing lenses, ensure that you don't touch anything inside the camera as the mirror and contacts are particularly delicate. You must never touch any of the glass surfaces with your fingers. Small dust particles can be removed with a bellows brush and you should only use a clean, dry cotton cloth with a drop of lens cleaner to clean the element surfaces or viewfinder eyepiece if this is absolutely necessary. In this case you need to clean the glass surface carefully, wiping in circular movements from the inside to the outside.

---

*If the sky in your photograph is to be the same deep blue as it is in your memories, a polarizing filter is advisable. (top)*
*With the Minolta eye-start system you won't miss any more snapshots. (bottom)*

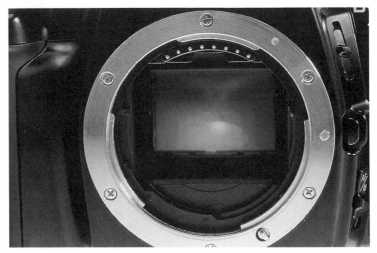

The bayonet of the 3xi with the contacts for the autozoom function.

The mirror must never be touched or even moved, as this could affect its alignment. Small dust particles on the mirror will not affect the functioning of the exposure metering or focusing systems. But if the dirt particles get too much, as is inevitable in the course of time, send the camera to a Minolta service centre in order to get the mirror cleaned.

## Camera position

The lens is attached, the battery inserted and the neckstrap fastened, so now you can start your first trial runs. One important prerequisite for successful shots is to hold the camera correctly. None of the automatic programs will help if the photographer's unsteady hand causes camera shake, but fortunately, the 3xi and SPxi are almost built into the photographer's hand. Thanks to their ergonomic shape you will hold it correctly almost automatically.

With your right hand you can keep a firm hold on the camera grip, so that middle finger, ring finger and little finger touch the sensor bar for the automatic camera activation. The index finger automatically comes to rest in the depression to the side of the shutter release button, and the thumb fits almost perfectly behind the raised form on the back of the camera. This way this light camera can be held comfortably with just one hand. You can then support the base plate of the camera with the palm of your left hand, as thumb and index finger grip the zoom ring of the lens. But you mustn't touch or hold the focusing ring of AF lenses. The front barrel of the xi series zooms and AF Power Zoom lenses must not be held either, as this interferes with automatic focusing.

If the main switch is set to **ON**, the camera is activated as soon as it is lifted to the eye. It automatically focuses on the subject area located in the focus frame of the viewfinder, analyses whether it is moving or still, and then selects the autozoom setting, AF mode and exposure program. At first you may find the camera's automatic zooming irritating when you look through the viewfinder. But in practice you will very quickly get used to taking the suggested cropping as a good starting point. In most cases only a minimal amount of adjustment from this point is needed, and often the camera's suggestion coincides with the photographer's preference. Experience has shown that even if the suggested cropping isn't quite what you had in mind, it is quicker to zoom from this setting to the desired position. However, the auto stand-by zoom function won't work if the sensor bar isn't touched, or if you are wearing gloves. In this case the framing has to be selected manually. The focusing and exposure control systems, on the other hand, are activated by touching the shutter release button lightly.

The automatic activation of the camera is achieved with the help of an infrared sensor set next to the viewfinder eyepiece. A transmitter gives out an infrared beam when the sensor bar is touched and as soon as an object approaches the viewfinder eyepiece, it refracts this beam back to the second cell, the receiver. This will now give the impulse to activate the automatic system of the camera. The eye-start system may not work if you are wearing sunglasses whose lenses absorb infrared light.

The autofocus and automatic exposure system will switch off after about four seconds if there is no longer an object near the viewfinder.

Nowadays camera shake is one of the most frequent causes of failure. To achieve a steady camera position, keep your elbows against your body and, if possible, lean on something. Stand with your legs slightly apart. Try to press the shutter release button as gently as possible, without jerking.

As we have already seen, the xi cameras automatically set the focus when you look through the viewfinder. It is not necessary to press the shutter release button lightly to do this, but the focus can be locked by lightly pressing the shutter release button. If, for example, the subject to be focused is not in the centre of the viewfinder, you simply need to aim the camera at it, press the shutter release button lightly, and then re-compose. The focus will remain locked for as long as you keep your finger on the shutter release button, or until the shutter is released.

# Operating controls

Externally, both cameras are very similar. The most important differences between the two are the integral flash unit of the 3xi and the spot metering function of the SPxi. The few buttons and switches are conveniently placed, and their function can be explained quickly. It doesn't take too much time to familiarize yourself with them, but you must do so if you want to make full use of the many possibilities on offer by these two cameras.

**Main switch**
In order to be able to take photographs with the 3xi or SPxi, the main switch must be set to the **ON** position. The power supply is cut off in the **LOCK** position, and all camera functions are locked. If no film is loaded, no indicators will be displayed on the data panel when the camera is switched on, but if film is in the camera, the cassette symbol and frame number will appear. If the film is full and rewound, the cassette symbol and the number **0** will flash. These two indicators will also flash when the camera is switched on and an exposed and rewound film is in the cassette chamber.

**Grip sensor**
When in contact with skin, the sensor bar on the front of the camera grip activates the infrared sensor on the viewfinder eyepiece - provided the main switch of the camera is **ON**. However, if you are wearing gloves, the sensor on the viewfinder eyepiece will not be activated.

**Eyepiece sensor**
When the grip sensor is touched, the transmitter of the eyepiece sensor emits an infrared beam. As soon as this is refracted by an object close to the receiver of the eyepiece sensor, the latter starts the automatic system of the camera. Autofocus, automatic exposure control and auto stand-by zoom (when an xi zoom lens is used) will start working. If the sensor recognizes that there is no longer an object close to the viewfinder eyepiece, it will switch off the camera functions after four seconds. It is advisable not to hold the camera by the handgrip or touch the grip sensor if you're not

shooting: the camera will also switch on if it is held close to the body, and waste power unnecessarily. Furthermore, many people find it irritating if the autofocus and zoom systems are working noisily when the camera is not in its shooting position at the eye.

**Shutter release button**
Touching the grip sensor is sufficient to activate the autofocus, the auto stand-by zoom function and the automatic exposure program. Alternatively, the automatic exposure program and autofocus can be turned on by lightly pressing the shutter release button. This is necessary, for example, when you have to wear gloves and the grip sensor doesn't activate the eyepiece sensor. Lightly pressing the shutter release button does not activate the auto stand-by zoom (ASZ) function. If the shutter release button is held pressed, the autofocus setting and exposure are locked for still subjects. The focus lock is indicated in the viewfinder by the focus signal changing from $^{(\cdot)}$ to $^{\cdot}$.

**Program reset button**
This is located to the left of the shutter release button and cancels all special functions programmed. The camera returns to fully automatic mode, with program control, autofocus and automatic flash. On the 3xi the integral flash unit pops up automatically if necessary. If a Minolta program flash unit is mounted on the SPxi, this will also be activated.

Used in conjunction with the shutter setting control, the program reset button also allows you to select the exposure mode. Apart from aperture and shutter priority, manual exposure control is also available.

**Shutter setting control**
Located in front of the shutter release button, this switch can be used to adjust the selected shutter speed in shutter priority or manual mode. Manual shutter speed selection is carried out in one-step increments. When you press the program reset button at the same time, this control can also be used to select the exposure mode. Pushing it to the left causes a shift from program to change from S (shutter priority), M (manual exposure mode) and A (aperture priority). Pushing the switch to the right changes the exposure functions in the reverse order.

## Aperture setting control

A further switch is located to the left of the camera bayonet. This is used to increase and reduce the aperture setting in manual exposure and aperture priority mode. The aperture is stopped down by pushing the switch downwards. The f/number increases. Pulling the switch upwards will reduce the f/number, and the iris diaphragm is opened wider. The adjustment is made in half-stop increments.

## Self-timer button

Clearly marked with the self-timer symbol, this button is located in front of the main switch. If you press it, the self-timer symbol will

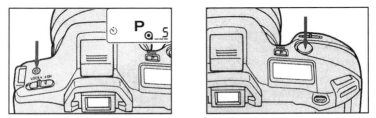

The self-timer is activated by pressing the button with the self-timer symbol. It is deactivated by pressing this button once more.

appear on the data panel to indicate that the countdown function has been activated and will delay the shutter release by approximately ten seconds. Once the shutter release button has been pressed, this symbol will flash throughout the entire countdown. The self-timer can be switched off at any time to interrupt the countdown. If the shutter release button has not yet been pressed, the self-timer function can be cut off simply by pressing the self-timer button again. During the countdown the self-timer can be switched off by setting the camera to **LOCK**.

The self-timer function is not only useful to appear in shots yourself. It is also a practical substitute for a remote controller when making long exposures from a tripod. The self-timer function has to be re-activated after every shot. Long exposures in the **buLb** setting are not possible with the self-timer.

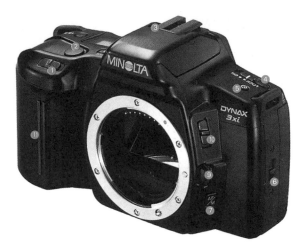

1. Shutter Setting Control
2. Shutter-Release Button
3. Built-in Flash
4. Main Switch
5. Self-Timer Button
6. Back-Cover Release
7. Focus-Mode Switch
8. Program-Reset Button
9. Lens Release

10. Aperture Setting Control
11. Grip Sensor
12. Film Window
13. Eyepiece Sensor
14. Flash-Control Button
15. Rewind Button
16. Body Data Panel
17. Pre-Flash Button

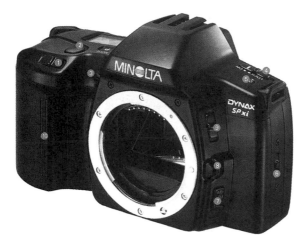

| | |
|---|---|
| 1. Shutter Setting Control | 10. Grip Sensor |
| 2. Shutter-Release Button | 11. Film Window |
| 3. Self-Timer light | 12. Eyepiece Sensor |
| 4. Main Switch | 13. Body Data Panel |
| 5. Self-Timer Button | 14. Program-Reset Button |
| 6. Back-Cover Release | 15. Spot-Metering Button |
| 7. Focus-Mode Switch | 16. Rewind Button |
| 8. Lens Release | |
| 9. Aperture Setting Control | |

If a program flash unit is mounted on the 3xi or SPxi and is ready to operate, the AF illuminator will flash three times before the shutter is released.

If the 3xi is set to the automatic program, the integral flash unit will emit three bursts of pre-flash light before the actual exposure. This pre-flash function can also be suspended and in other operating modes it will only work if the flash unit has been popped up.

### Lens release
The middle button of the three controls on the side of the bayonet is used to release the lens. When pressed it allows the lens to be turned anti-clockwise and removed from the bayonet. When mounting a lens, it will lock into position with an audible click.

### Focus mode switch
The bottom switch next to the camera bayonet is used to switch between automatic and manual focus mode. It's useful when automatic focusing is not possible because of low subject contrast or low light, or if autofocusing fails for different reasons. In low light the integral flash unit of the 3xi will emit a metering flash to support the focusing system. If you've an SPxi, however, a Minolta program flash unit with infrared light must be used for autofocusing in darkness. To switch the autofocus back on, simply push the switch downwards a second time, or press the program reset button.

### Rewind button
This is a small button located on the bottom left-hand side of the camera base that's slightly recessed into the body to protect it from accidental operation. A sharp object, such as a pencil or biro, is needed to operate it.

### Battery cover lock
The cover of the battery chamber on the base of the camera is secured by an automatic lock. To open the chamber, you simply push the cover release in the direction of the arrow indicated on it. The chamber is locked automatically when the battery cover is pressed down.

### Pre-flash button
Only the 3xi has a button next to the data panel which switches on

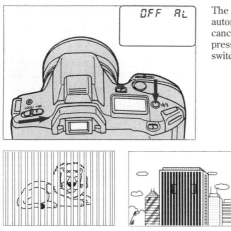

The 3xi has a pre-flash function for automatic focusing in low light. To cancel this function, you need to press the flash control button as you switch on the camera.

There are subjects which are too difficult for the autofocusing. This can be the case, for example, when objects at different distances are located in the focus frame, with dark and bright patterns or subjects of very little contrast.

and off the pre-flash function to reduce the chance of 'red-eye ' with flash shots. When the pre-flash function is activated, the integral flash unit fires a series of weak pre-flash pulses before the actual exposure. This causes your subject's pupils to contract so that the red retina will be less noticeable in the photograph.

The pre-flash button is also used to switch off the AF illumination of the integral flash unit. To do this, first press the pre-flash button as the main switch is pushed from **LOCK** to **ON**. To re-activate the AF illuminator, simply repeat the process.

**Flash control button**

The button on the back of the 3xi, next to the place where your thumb comes to rest, manually switches on the fill-in flash function, regardless of the light conditions. If the integral flash is popped up by pressing this button, in P mode it fires at every exposure while the button is held in.

Because the flash is not activated automatically in aperture and shutter priority, or in manual exposure mode, it needs to be switched on with the flash control button. This button also switches off the automatic flash in the automatic program, when the integral flash unit has popped up. To re-activate the automatic flash, simply press the flash control button a second time, or press the program reset button.

In combination with the shutter setting control, the flash control button is also used to program wireless remote flash control in conjunction with the 3500xi program flash unit.

**Spot metering button**
Unlike the 3xi, the SPxi has a spot metering option. The spot metering button on the back of the camera (in the same position as the flash control button of the 3xi) is used to switch from eight-segment honeycomb pattern metering to spot metering. When the spot metering button is pressed, the exposure metering area is restricted to the area bounded by the circle in the viewfinder. If a flash unit is used in the automatic program and in shutter and aperture priority modes, the spot metering button activates the flash synchronization function for long exposures. The spot metering button has to remain pressed during the exposure.

**Back cover release**
The back cover is opened by pressing down the release switch on the left-hand side of the camera. It locks simply by pressing the cover shut. When a film has been loaded, the camera will automatically advance it to the first frame as soon as the back cover is closed.

# Viewfinder displays

As the 3xi and SPxi cameras are intended for carefree photography with a high degree of automation, the indications in the viewfinder are kept to a minimum. The indicators for autofocus function, exposure and flash operation appear to the right of the viewfinder image. Apart from these, the focus frame is indicated in the centre of the focusing screen.

## Focus signals

A small green circle inside two green brackets shows that continuous focus mode is activated and the camera has focused on the subject in the focus frame. If the subject is still, once the focus has been found, the indication changes to the slightly larger green LED set underneath. This signal will flash if the AF system can't find the focus.

## Exposure signals

Two triangular amber LEDs monitor the exposure control system. Both are lit permanently if a correct exposure can be expected. They flash for incorrect exposure, either because the light levels are outside the working range of the camera, or because the photographer has chosen a shutter speed or aperture setting in A, S or M mode that make an under- or overexposure likely.

In manual mode the lower triangle warns of underexposure. It flashes if an activated flash unit isn't fully charged. In aperture priority it also warns of the danger of camera shake when slow shutter speeds are necessary. The upper triangular LED will light up if the light conditions are such that an overexposure is likely.

## Flash signals

Depending on the flash function, different flash signals - single or double - become visible in the viewfinder. The single flash symbol winks slowly when the flash is ready to fire. It flashes rapidly to confirm a correct flash exposure.

The double flash symbol indicates that the pre-flash function has been activated. In this case slow and rapid flashing have the same meaning as with the single flash symbol. The single and double symbol will flash alternately to remind the photographer that the camera has been set for wireless remote control of an off-camera flash unit.

## Focus frame

Two rectangular brackets in the centre of the viewfinder of the 3xi and SPxi enclose the focus frame. The camera sets the focus according to the portion of the subject located in this frame. To be able to track a subject with the predictive autofocus function, all or part of the subject must lie within this focus frame.

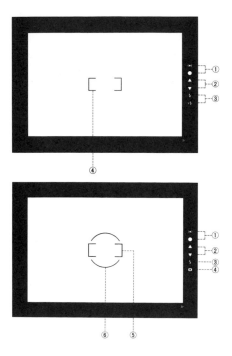

### Viewfinder displays 3xi

1 Focus signals
2 Exposure signals
3 Flash signals
4 Focus frame

### Viewfinder displays SPxi

1 Focus signals
2 Exposure signals
3 Flash signals
4 Spot metering indicator
5 Focus frame
6 Spot metering area

## Spot metering area

In addition to the rectangular brackets for the focus frame in the centre of the SPxi's viewfinder, two semi-circular brackets enclose the spot metering area. This circle only takes up roughly 4.1% of the entire viewfinder area.

# Data panel

The data panel is the most important information centre of the 3xi and SPxi, indicating all the settings and functions relevant for a particular shot. Some settings are only visible when they are being selected, others only appear while a certain function is activated or carried out.

**Battery condition indicator**
Every time the camera is switched on, the charging state of the battery is checked and indicated by the battery symbol.

**Exposure mode indicators**
The letter **P** for the fully automatic program appears in the very centre of the data panel. This will light up every time the program reset button is pressed when the camera is switched on. Aperture priority is indicated by a large **A**, shutter priority by a large **S**. Manual exposure mode is signalled by the letter **M**. The exposure mode is selected by pressing the program reset button and using the shutter setting control.

**Manual focus mode indicator**
The indication **M.FOCUS** appears inside a frame on the data panel when the camera is switched from automatic to manual focusing. This can be set either by using the focus mode switch on the camera, or by pulling back the zoom ring on new Minolta autozoom or power zoom lenses.

**Self-timer indicator**
The self-timer symbol appears when the self-timer button is pressed. It is removed in the same way. The function can also be cancelled by switching off the camera or with the help of the program reset button. The symbol will flash during the self-timer countdown, and the function has to be re-activated after every exposure.

**Flash mode indicators**
A single flash symbol and the letters **AUTO** appear when the automatic flash is activated by the program mode. If the pre-flash function also operates, the double flash symbol with the letters **AUTO** appears. In A, S and M mode the single or double flash

symbol only comes on if both functions are activated by pressing the flash control and pre-flash buttons. If the camera has been programmed for wireless remote flash control both symbols will flash. On the SPxi the flash symbols only appear if a Minolta program flash unit is fitted and switched on.

### Shutter speed and aperture displays

The shutter speed is shown on the centre of the top line of the data panel, the aperture on the right. The settings that can be selected by you in a preselected exposure mode are indicated by triangular pointers; left (shutter speed) and right (aperture). Camera settings will flash if an incorrect exposure is expected. The value which actually flashes in either case is described with the different exposure modes.

The line containing shutter speed and aperture displays is also used to show special programmed functions:

   * **Lens attachment** - When two lines (—) appear instead of the aperture display, either no lens is attached, or a lens is incorrectly mounted. It could also mean that the AZ/MZ switch of an xi lens is set to **MZ**.

   * **ASZ function indicator** - If the auto stand-by function (ASZ) of Minolta zoom lenses is switched off, the letters **OFF AS** will appear on the data panel. To switch this off, the function button on the lens must be pressed and the main switch of the camera must be pushed from **LOCK** to **ON**. To switch ASZ back on, simply repeat the process, and **ON AS** appears on the data panel. This display disappears when you let go of the lens function button.

   * **Remote flash control indicator** - To program the 3xi for flash control, you need to push the program flash unit 3500xi onto the camera and switch it on. By pressing the flash control button and moving the front control switch, you can now switch the remote flash control function on or off just by selecting **ON** or **OFF** on the data panel. At the same time, the flash symbols on the data panel flash alternately.

   * **AF illumination function indicator** - On the 3xi the AF illuminator to support the AF system can be switched off. Do this by pressing the pre-flash button and slide the main switch from **LOCK** to **ON** when the indication **OFF AL** will appear on the data panel. The AF illuminator is switched on again by repeating the process and **ON AL** will appear on the data panel. Once again, these

indications disappear as soon as you let go of the pre-flash button.

 \* **bAtt indicator** - When the camera is switched on and the battery is too low, the flashing **bAtt** indicator will appear in place of the shutter speed display. Contrary to the instruction manual, it disappears as soon as the main switch is set to **LOCK**. The low battery symbol will continue to flash after the camera has been switched off.

 \* **HELP indicator** - The film transport function is faulty if the letters **HELP** appear on the data panel. Inserting a fresh battery will usually help, but if the symbol still appears you should return your camera to an authorised service centre.

**Frame counter**
The figure **0** appears on the frame counter in the bottom left-hand corner of the data panel if no film is loaded. If the figure **0** flashes together with the cassette symbol and the film transport signals, the film is loaded incorrectly. If only the **0** and the cassette symbol flash, the film was either rewound automatically after the last frame or rewound manually and only partially exposed. The cassette symbol, film transport signals and frame number are permanently visible if the camera is switched, on and the film is winding on correctly.

## Minolta Dynax 3xi LCD Panel

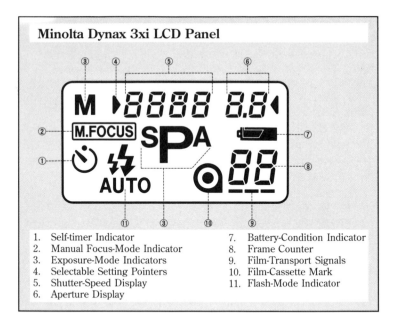

1. Self-timer Indicator
2. Manual Focus-Mode Indicator
3. Exposure-Mode Indicators
4. Selectable Setting Pointers
5. Shutter-Speed Display
6. Aperture Display
7. Battery-Condition Indicator
8. Frame Counter
9. Film-Transport Signals
10. Film-Cassette Mark
11. Flash-Mode Indicator

## Minolta Dynax SPxi LCD Panel

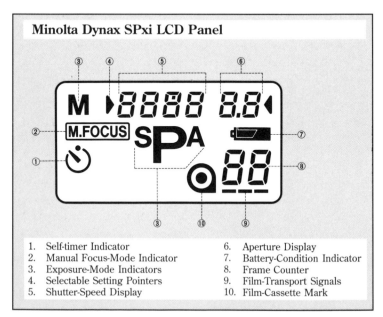

1. Self-timer Indicator
2. Manual Focus-Mode Indicator
3. Exposure-Mode Indicators
4. Selectable Setting Pointers
5. Shutter-Speed Display
6. Aperture Display
7. Battery-Condition Indicator
8. Frame Counter
9. Film-Transport Signals
10. Film-Cassette Mark

# Film loading

Film loading is sheer pleasure with today's motorized cameras sporting automatic threading and advance. It's easy to almost forgot the good old days when fiddling around trying to stick the film leader into take-up spool slots was normal. With Minolta's Maxxum/Dynax cameras all you need do is open the back cover, place the film cassette in the film chamber and pull the film leader to the right until it reaches the film leader index. Then simply close and press down the back cover and the film will be advanced to the first frame as if by magic.

If you accidentally pull out the film leader too far, so that it extends beyond the film leader index, take the film back out of the camera and carefully rewind it a little. Films with ripped or creased film leaders can also cause problems for the threading mechanism because the sprockets of the transport spool in front of the index mark must engage the lower perforations of the film.

The film speed is automatically read off the film cassette and transmitted to the computer for exposure control purposes. Thanks to automatic film speed registration, only DX-coded films can be used in the 3xi and SPxi although the camera automatically sets ISO $100/21°$ with un-coded films. The automatic film speed registration works in one-third increments on films between ISO $25/15°$ and $5000/38°$, but the automatic flash control system of both cameras, however, is only designed to work up to ISO $1000/31°$.

Before loading a film, or rather opening the camera back, it's a good idea to look at the data panel and through the film window. If there is still film in the camera, opening the back cover can spoil the shots you've taken. The light entering during accidental opening becomes visible as a bright, wide stripe on the affected shots. The frame counter also returns to **1** when the back cover is closed.

Partially exposed films have to be rewound before they can be taken out. Film rewind is activated by pressing the rewind button on the underside of the camera. Once rewinding has been completed, the figure **0** and the cassette symbol flash on the data panel and films are automatically rewound at the end, after the last exposure. With a 36-exposure film this takes around 18 seconds, although a 24-exposure film will be rewound in just 12 seconds. If the battery is too flat to complete rewinding, the process continues as soon as

The frame counter is set to zero when there is no film in the camera.

Once the back cover is closed, the camera automatically advances the film to the first frame.

If the film was loaded incorrectly, the frame counter stays at zero and flashes and the shutter cannot be released.

a fresh battery is inserted, without any need to press the rewind button once again.

To prevent light from entering through the opening in the film cassette, don't change films in bright sunlight. If you must, at least do it in your own shadow.

Whatever you do, don't forget to remove the protective foil from the film channel of new cameras.

If the film has been loaded correctly, the figure **1** will appear on the data panel once the back cover has been closed, indicating that the first shot can be taken. When loaded incorrectly, the frame counter stays on **0** and this and the cassette symbol on the data panel flash. Just open the back cover and re-load the film. The camera has to be set to **ON** for film loading.

*The integral flash of the 3xi ensures correct lighting in all light conditions.*
*Photo: Barbara Maurer*

# Expert autofocus

In contrast to many other AF cameras, the switching between focus lock and continuous focus mode is automatic on the 3xi and SPxi, so manual focus mode selection is unnecessary. Both cameras recognize when a subject is moving or still, and set the relevant operating mode automatically. As you look through the viewfinder the expert autofocus system is activated and sets the continuous focus mode. If the computer recognizes that the subject is moving, it also calculates its speed. As soon as you press the shutter release button, the camera uses this calculation to focus the lens to a point where the subject will be at the precise moment when the shutter runs. In this way the autofocus system of the 3xi and SPxi calculates the distance travelled by the subject in the time between the first shutter release impulse to the mirror flipping up and the closing of the iris diaphragm. It pre-calculates the position where the subject can be expected to be found. This automatic focusing system, introduced by Minolta under the name predictive autofocus, delivers excellent results even with fast-moving subjects. Compared to cameras by other manufacturers, the 2.6x6.8mm focus frame is relatively large, which makes it easier to aim at a moving subject and keep it within the focusing area.

Like almost all AF SLR cameras, the AF system works with CCD sensors using the phase comparison principle. Here part of the light entering the camera is not directed to the viewfinder but falls through the mirror onto an infrared block filter instead. It is then concentrated by a collecting element and re-directed onto two rows of sensors through a separating mask and a divider element via a secondary mirror. If the subject is in focus, the divided light-rays hit the same sensors on each of the two CCD rows. Accurate and fast focusing even in low light is guaranteed by the high sensitivity of

*The eye-start system and motorzoom are ideal for photojournalism, such as this shot of the Basle carnival. Photo: Barbara Maurer*

the sensors and the high calculating capacity of the integral computer control system in the Minolta 3xi and SPxi. The most advanced fuzzy logic software and the fast response of the AF motor are a great help too.

Although Minolta states that extremely fast subjects, as well as abrupt changes in speed or direction, can be too much for the continuous focus control system, such situations seem extremely rare in practice. The working range of the AF system lies between -1 and 18 EV.

As soon as the camera is activated by a glance through the viewfinder, it works in continuous focus mode. A green LED indicator (°) for continuous focusing appears at the top right-hand side of the viewfinder to signal that the camera has focused on the subject using the wide focus frame.

When the shutter release button is pressed halfway, the distance setting is locked, provided the lens is not moving and the green LED indicator ° appears in the viewfinder. If the subject is moving, however, the camera will stay in continuous focus mode.

Thankfully, Minolta engineers decided to forego audible focus confirmation. Apart from being simply irritating and drawing everybody's attention to you, this feature probably didn't serve much purpose.

As I have already mentioned, when focusing on stationary subjects the distance is locked by a light touch of the shutter release button. When using an xi zoom lens, or an AF power zoom, you can also lock the focus setting by pulling the zoom ring towards the camera. But be careful not to turn the ring in the process or focus may be altered.

## AF illuminator of the 3xi

The 3xi can't just focus in low light, but also works in complete darkness. If the camera realizes that there is insufficient subject contrast for correct automatic focusing, the integral flash unit emits a series of weak auxiliary flashes when the shutter release button is pressed lightly. The light of these pre-flashes allows the AF system to focus even in complete darkness over a range between one and five metres. There are shooting situations, though, when you have to do without the AF illuminator. This could be when its

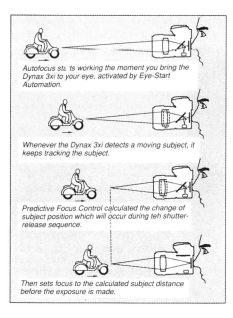

Autofocus starts working the moment you bring the Dynax 3xi to your eye, activated by Eye-Start Automation.

Whenever the Dynax 3xi detects a moving subject, it keeps tracking the subject.

Predictive Focus Control calculated the change of subject position which will occur during teh shutter-release sequence.

Then sets focus to the calculated subject distance before the exposure is made.

The Minolta Maxxum/Dynax cameras continue focusing on moving subjects right up until the actual moment of exposure. The predictive autofocus registers every change in the subject distance and uses this data to calculate the correct focus position.

light would be distracting, or because the subject is out of its range and you have to do without flash and AF illuminator. The AF illuminator can be switched off in such situations by pressing the pre-flash button as you slide the main switch from **LOCK** to **ON**. The letters **OFF AL** will then appear in the top line of the data panel of the 3xi. The AF illuminator is switched on again by repeating this process. In this case the letters **ON AL** will appear in the top line of the data panel. The indication disappears as soon as you let go of the pre-flash button.

If you are photographing in automatic program mode, the AF illuminator switches on automatically when required. But this only works if the shot itself also requires flash light to gain a correct exposure. If the flash has been switched off, to make a long exposure for example, the AF illuminator function is suppressed at the same time. Switching off the red-eye reduction flash function has no influence whatsoever on the AF illuminator.

If you are working in aperture or shutter priority, or in manual exposure control mode, the integral flash unit has to be popped up - by pressing the flash control button - in order to switch on the AF illuminator.

With the SPxi, a Minolta program flash unit with AF auxiliary light is required for automatic focusing in darkness.

## Manual focusing

There are shooting situations when even the best autofocus system fails. In such cases the 3xi and SPxi can be switched to manual focusing mode. For the Minolta AF lenses this is done using the focus mode switch on the camera body. Minolta xi autozoom or power zoom lenses allow manual focusing simply by slightly pulling the zoom ring towards the camera. Focusing is then carried out by the motor, in a similar way to focal length adjustment, by slightly turning the zoom ring.

AF lenses are focused manually by turning the manual focus ring. The focus is confirmed by the electronic focus signal in the viewfinder and here the round, green LED lights up in the viewfinder as soon as the subject in the focus frame is sharp. In critical situations the electronic focus signal won't work, either. In this case the focus has to be determined visually via the viewfinder matte screen.

Situations when you may have to switch to manual focus mode are shots of monochrome areas with little contrast. The AF control system will also have difficulty if subjects with alternating light and dark stripes fill the focus frame. It will also have problems if subjects at different distances are located within the focus frame.

The letters **M.FOCUS** appear on the data panel when you switch to manual focusing, whether you press the focus mode switch on the camera or pull the zoom ring. To switch back to the AF function, you either need to press the focus mode switch once again, or press the program reset button. In manual focus mode the shutter can be released at any time, regardless of whether or not the subject is sharp.

# Exposure metering

The Minolta 3xi and SPxi have a new type of honeycomb pattern metering system to determine the correct exposure. The exposure is metered by a highly sensitive silicon photo cell consisting of eight segments. The weighting of the different segments can be changed to adjust the metering emphasis placed on the subject, and this depends on the reproduction ratio and the autofocus. In addition, both cameras have a further silicon photo cell for the TTL flash control system. The SPxi can also use the centre segment of the honeycomb pattern metering system for spot metering.

## Honeycomb pattern metering

Both cameras have the honeycomb pattern metering system with eight segments, developed by Minolta. The silicon photo cell divides the image area of the cameras into seven hexagonal segments arranged in a honeycomb pattern and one segment to determine the background brightness. The brightness is metered separately in each segment. The data from each segment helps the automatic exposure system to recognize the position of the main subject and to adjust the weighting of the metering segments according to this position. The honeycomb pattern metering system determines how much light is available for the exposure, in order to adjust aperture and shutter speed accordingly. Additionally, it recognizes differences in brightness in the subject and compensates for these differences, so that bright and dark parts of the subject still have as much contrast as possible in the shot, and to ensure whenever possible that the normal contrast range of the film is not exceeded. The working range of the honeycomb pattern metering system of both cameras lies between 1 and 20 EV with an ISO 100/21° film and a 50mm,f/1.4 standard lens.

In automatic program mode the integral flash unit of the 3xi automatically fills in dark parts of the subject to prevent excessive contrast. The SPxi, which doesn't have an integral flash unit, needs a Minolta program flash unit in order to do this. When used with a program flash unit and set to the automatic program mode the SPxi,

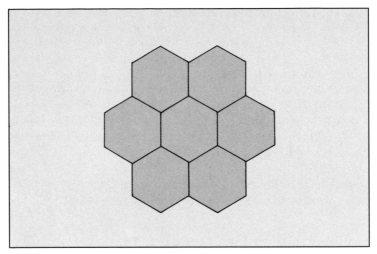

The silicon photo diode of the exposure metering system divides the image area of the camera into seven hexagonal areas arranged in a honeycomb pattern. There's also a segment to evaluate background brightness.

too, ensures a reduction in subject contrast by means of auto fill-in flash. The fill-in flash operation of both cameras is described in detail in the chapter on flash photography.

## Spot metering with the SPxi

In addition to honeycomb pattern metering, the SPxi also offers spot metering for precise exposure control. This metering mode makes sense whenever certain parts of the subject are to be emphasized and must receive optimum exposure. In the spot metering system of the SPxi the metering area is reduced to the centre segment of the honeycomb pattern where it takes up approximately 4.1% of the entire image area. The metering area is indicated by the two semi-circles engraved on the viewfinder screen.

Spot metering requires some experience in exposure metering. Every exposure measurement is adjusted to the reflectance of

medium grey subjects. But our world isn't grey, it's full of colours and different colours reflect light to different degrees. So if spot metering is used, you have to meter a colour with roughly the same reflectance as a medium grey, to prevent incorrect exposure. Dark colours reflect less light, so the camera thinks the shot is darker than it really is and will expose more generously. The consequence is a more or less pronounced tendency towards overexposure. Conversely, metering strongly reflecting bright colours will lead to underexposure, as the camera thinks the scene is more brightly lit than it actually is. So when using spot metering, you should be careful which subject detail you measure. Colours whose reflectance roughly corresponds to a medium grey are green fields (not too dark), the asphalt or pavements of streets, and also skin tones. The latter allows you to meter from your palm held in front of the camera, or directly on the face of a subject.

For an accurate measurement, the metered detail should fill the entire metering circle in the viewfinder of the SPxi. You may need to go closer to the subject and then recompose after metering. The measurement remains locked for as long as the spot metering button remains pressed. This button also has to remain pressed when the shutter is released.

Spot metering is done as follows. First aim at the subject, and place the relevant detail in the viewfinder in so that it fills the entire metering area. Go closer to the subject if necessary. Finally compose while holding down the spot metering button, and then release the shutter.

The working range of the spot metering system lies between 4 and 20 EV with an ISO 100/21° film and a 50mm,f/1.4 standard lens. You can see that it's slightly reduced compared to honeycomb pattern metering. Spot metering activation is indicated on the lower right-hand side of the viewfinder. In TTL flash control mode spot metering cannot be used for flash exposure metering. When flashing in aperture or shutter priority as well as automatic mode, the spot metering button is used for slow shutter sync.

# Exposure control

The 3xi and SPxi each have five different exposure control modes. Depending on the photographic situation, you can choose between automatic program (P), aperture priority (A), shutter priority (S) and manual shutter speed and aperture control (M). In addition, automatic TTL flash mode can be used in all exposure modes and works both with the integral flash unit of the 3xi and with separate program flash units for both cameras. The integral flash of the 3xi also allows wireless remote control of a second off-camera flash unit.

In order to select the exposure mode, you need to press the program reset button labelled **MODE** and **P**. The camera will automatically switch to automatic program mode. To select a different function, you need to hold down the button and select the desired exposure mode with the shutter setting control. The selected exposure function will be maintained when the program reset button is released, and the selection checked on the data panel.

## Automatic program

Pressing the program reset button is enough to set the 3xi or SPxi to the automatic program. The large **P** in the data display indicates that the camera will now control all functions automatically. The automatic program is probably the standard setting for working with the 3xi and SPxi. In this mode the camera will automatically decide all necessary settings and functions.

It will select the AF function mode and set the shutter speed and aperture required for a correct exposure. But although most SLR cameras select the aperture/shutter speed combination solely according to focal length, the 3xi and SPxi are not limited to a single program characteristic.Instead both can select shutter speed and aperture from a whole range of possible exposure settings. With the help of its software, designed on the principles of the new fuzzy logic system, the expert exposure program adapts its settings to the

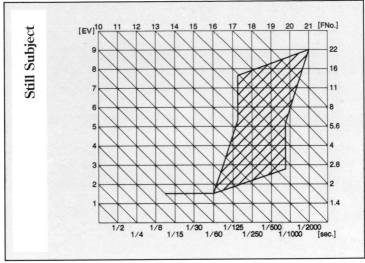

Minolta expert program selection for still subjects.

entire photographic situation. In order to set aperture and shutter speed to suit the subject as precisely as possible, the cameras takes into account, subject brightness, shooting distance, reproduction ratio, the lens focal length and camera movement when making its calculations. Cleverly the camera will recognize, for example, whether it is dealing with an action snapshot, a landscape shot or a close-up shot.

It even recognizes whether or not flash light is needed to fill in because the differences in brightness in the subject are too great. The integral flash unit of the 3xi is switched on automatically when required, either when the light is too low or to fill-in strong contrast. In this operating mode, a Minolta program flash unit attached to the camera and switched on is also fired automatically when required. With a program flash unit attached, the flash functions of the 3xi are identical to those of the SPxi.

The viewfinder indicators signal the current operating state of the flash unit. The underexposure signal flashes whilst the flash unit is being charged and as soon as the unit is ready to flash, the flash symbol in the viewfinder flashes slowly. This same symbol will

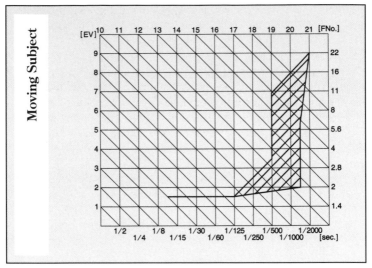

Minolta expert program selection for moving subjects.

also flash after the shutter has been released, this time in quick succession, to indicate that a correct flash exposure has been made. When the pre-flash function is selected, these indications are given in the viewfinder of the 3xi by the double flash symbol.

If the 3xi and SPxi are to fire an attached flash unit automatically, this unit has to be switched on. The integral flash unit of the 3xi, on the other hand, switches on automatically, but this automatic flash function can also be deactivated. Do this by pressing the flash control button on the back of the 3xi while pushing down the flash unit. The automatic flash function is re-activated by pressing the button for a second time, or by pressing the program reset button. When the automatic flash function is selected, the letters **AUTO** appear on the data panel, underneath the flash symbol. If the flash is activated manually, only the flash symbol (the double flash symbol if the pre-flash function is activated) will appear. Nothing shows if the automatic flash function is deactivated.

If the 3xi recognizes by the lighting conditions when fill-in flash is required, it will switch it on automatically. But you can also switch

54

it on manually if the camera itself doesn't deem it necessary. To do this, you pop up the flash by pressing the flash control button but to ensure it will definitely fire, the button needs to remain pressed during the exposure.

In the automatic program the SPxi and 3xi set the shutter speed continuously in a range between 1/2000 and 30 sec. All available lens apertures are taken into account and are controlled in half-stop increments. When flashing, the fastest flash sync speed of 1/90sec is set automatically but to get slower flash sync speeds press the flash control button on the back of the 3xi, or the spot metering button of the SPxi.

Shutter speed and aperture are indicated in the top line of the data panel when the shutter release button is pressed lightly.

## Aperture priority

When shooting in aperture priority mode, the desired aperture is preselected, and the camera automatically and continuously selects the corresponding shutter speed. To switch to aperture priority, hold the program reset button pressed as the shutter setting control is pushed to the right. The indication **A** appears on the data panel. If you've forgotten which way to push the shutter setting

Aperture priority mode is set using the shutter setting control when you press the program reset button. The aperture is selected with the aperture setting control positioned next to the camera bayonet.

control, you can push it in either direction until the **A** appears on the data panel. As soon as you release the program reset button, the aperture priority mode is activated.

The aperture display will then appear on the top right-hand side of the data panel, next to a pointer. The aperture can now be preselected with the aperture setting control at the top left-hand side of the camera bayonet. The setting is done in half-stop increments and as you push the aperture setting control up, the aperture becomes wider. Conversely, if you push it down it becomes smaller. Remember that the aperture range available depends on the lens.

If you now press the shutter release button lightly, the shutter speed is automatically selected by the camera to suit the preselected aperture and is displayed to its left on the data panel. The automatic shutter speed range lies between 1/2000 and 30 sec and is controlled continuously and shown in approximately half-step increments. If incorrect exposure is likely because a sufficiently fast or slow shutter speed isn't available to match your preselected aperture, the fastest or slowest shutter speed will flash on the data panel. If the fastest shutter speed is flashing, the aperture has to be stopped down for a correct exposure. If this is not possible, using a slower film can solve the problem of impending overexposure. Another possibility is to reduce the light intensity with a neutral density filter. If the indication for the slowest shutter speed is flashing, on the other hand, you either need to open up the aperture further, load a faster film, increase the light intensity, or use flash.

In parallel with the warning signals on the data panel, the two triangular exposure signals in the viewfinder flash to request exposure adjustment. They will also flash if the working range of the exposure metering system has been exceeded because the light is too dim or too bright.

If the flash unit is switched off, the downward-pointing triangular LED will flash if the shutter speed is too slow for handheld shots without camera shake. In this case you either use a tripod, or select a wider aperture to achieve a faster shutter speed.

## Shutter priority

To switch to shutter priority, press the program reset button and push the shutter setting control to the right. Shutter priority is activated when you release the program reset button. The indication **S** will appear on the data panel and directly above it, next to a triangle symbol pointing to the right, the preselected shutter speed. If you now press the shutter release button lightly, the aperture set by the camera will appear next to it. If the maximum aperture of the current lens is flashing, there is a danger of underexposure. You either need to select a slower shutter speed, increase the light intensity, or use a faster film. If, on the other hand, the narrowest

Shutter priority mode is set with the shutter setting control while pressing the program reset button. A pointer will appear next to the shutter speed display. But to set the shutter speed, push the shutter setting control to the left or right.

aperture of the current lens is flashing, overexposure is a threat. You therefore need to select a faster shutter speed or a slower film. Reducing the light intensity is, of course, another remedy, but usually the photographer will have no influence over this.

In both cases - when over- or underexposure threaten - both triangular LEDs in the viewfinder will flash as a warning. They will also flash if the light conditions exceed the metering range of the camera. As the shutter speed was freely preselected, the automatic system of the camera does not give the camera shake warning when the shutter speed is too slow. The reciprocal of the focal length is

taken as the slowest shutter speed for handheld shots without camera shake. With a 500mm lens, for example, this would be 1/500sec.

The long exposure setting **bulb** can be selected in shutter priority mode, but it will not produce a correct exposure. As soon as the letters **bulb** appear on the data panel, the two triangular LEDs will flash in the viewfinder and the smallest aperture will light up on the data panel. Correct exposure can't be guaranteed.

## Manual exposure control

With the 3xi and SPxi the photographer can also select shutter speed and aperture accordingly to achieve certain effects. To change to manual exposure mode, the program reset button needs to be pressed once again, and the shutter setting control pushed to the left twice until an **M** symbol appears top left on the data panel. To its right shutter speed and aperture values will appear, framed by two black triangles.

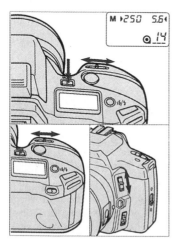

To set manual exposure mode, select the **M** position with the shutter setting control when the program reset button is pressed. The shutter speed is selected with the shutter setting control on the camera grip, the aperture with the aperture setting control on the camera bayonet.

You now have the chance to select the shutter speed in full-step increments from 1/2000 to 30 sec, and use long **bulb** exposures. The aperture can be set in half-stop increments using the aperture setting control to the left of the camera bayonet but the range at your disposal depends on the speed of the current lens. The aperture/shutter speed combination can be selected freely, but the camera tells you in the viewfinder whether a given combination will lead to under- or overexposure. Both triangular LEDs in the viewfinder light up if the exposure setting is correct but if overexposure threatens, only the upward-pointing LED will come on. With underexposure, on the other hand, only the lower triangular LED will be lit. Should both LEDs flash, the lighting conditions are outside the metering range of the camera.

On long exposures, using the **bulb** function, the camera shutter will stay open while the shutter release button is pressed. You need to put the camera on a tripod and set the camera to **bulb** via the shutter setting control. As long exposures in the **bulb** setting are usually made in very dim light, the autofocus is unlikely to work. In this case it's best to switch to manual focusing and use the viewfinder. Having focused, the viewfinder eyepiece needs to be covered by the eyepiece cup to reduce the risk of stray light affecting the exposure.

## Which exposure function is best?

The Minolta 3xi or the SPxi will cope with most shooting situations thanks to the expert exposure control system in the P mode. Unlike most cameras, its fuzzy logic software that's programmed with expert knowledge, not only takes into account subject brightness, but also considers things like the reproduction ratio, subject movement and position. In many ways it works the same way as an experienced photographer. This type of exposure control system will certainly achieve the highest success rate. It will always deliver correctly exposed photographs and, when the camera is held carefully, shake-free shots without any blur. Snapshots, photojournalism, group shots, shots of family events are all areas where the automatic program is excellent. But whether the correct exposure is right to gain a particular effect is a completely different matter. Also, photographers often deliberately use sharpness and

unsharpness as important creative tools. They can use the blur created by fast movement to deliberately create effects which greatly increase the impression of speed. On the other hand, you might want to precisely influence the depth of sharpness, to limit it or to extend it as you choose.

Shutter priority mode is one option for gaining sharp or blurred subjects. You can use it to preselect a shutter speed that is either fast enough to freeze a movement, or so slow that a moving subject can only appear as a blur. How slow or fast a shutter speed needs to be depends not only on the speed of the subject, but also on its direction of movement. If the subject is moving towards the camera, the shutter speed does not need to be as fast as it does when it moves at a right angles to the lens axis. Freezing the explosive start of a 100m sprinter, for example, is often the only way of making certain phases of a movement visible.

For such action shots it's best to load the camera with an ISO 400/27° colour negative film, select shutter priority (S) and preselect a shutter speed between 1/500 and 1/2000 sec, depending on the speed of the subject. In difficult light you can also work in aperture priority mode (A). The photographer preselects the maximum aperture (smallest f/number) and the camera will always automatically select the fastest possible shutter speed.

But if you want to give the viewer the impression of speed through unsharp streaking effects, you should use aperture priority (A) mode and stop down the aperture until you reach a shutter speed of 1/30sec or longer. However, shots where the subject itself is sharp and the background is blurred are usually more effective. Do this by setting the camera to the same mode and follow the movement of the subject with the camera during the exposure. This technique is known as panning. A tripod with a panning arm on the head is a practical help to achieve even movement of the camera during the exposure, following the speed of the movement. To freeze movement you need to set the camera to shutter priority and preselect a sufficiently fast shutter speed. If the light conditions are critical, aperture priority can help. Preselect the maximum aperture, and the camera will automatically select the fastest possible shutter speed. To create streaking effects, on the other hand, you can use shutter priority.

Aperture priority is the best mode to use for controlling the depth of field, the zone in front of and behind the point of focus that will

An effect of movement created by panning the camera during a long exposure.
Photo: R. Hagenauer

be rendered sharp on the final picture. The wider the aperture set, the narrower this zone is. Conversely, the depth of field increases as you stop down towards smaller apertures.

Good photographers use this technique to enhance the composition. Select a suitably small or wide aperture in aperture priority mode, and the camera automatically takes care of the shutter speed. Landscape shots with wide-angle lenses, where there is no danger of camera shake or blur, are ideal for aperture priority. On the other hand, shots where the photographer chooses to make the background unsharp are also excellent with aperture priority mode.

So controlling the depth of field is the domain of aperture priority. It can be used to create deliberately slow shutter speeds - if the camera is mounted on a tripod, for example, or if a wide-angle lens is used. On the other hand, it can also help to make unwanted subject details in the foreground or background disappear. While great depth of field is required in landscape and architectural photography, shallow depth of field is particularly effective for portrait shots. But the ability to separate the subject from the background is also a substantial creative tool in action photography or photojournalism, where the photographer can't freely choose the surroundings of a subject, let alone create it.

All these effects can, of course, also be achieved by manually selecting shutter speed and aperture. But this demands a lot more care on the photographer's part, who has to pay close attention to every cloud, every change in lighting. However, manual exposure

mode has additional advantages. Many photographers expose films at speeds that differ from their manufacturers rating. With the Minolta 3xi and SPxi you can't see the amount of the deviation, but you can still determine it precisely, although it is a little complicated. First meter the light conditions in the camera's automatic mode, read the settings off the data panel and then set manually the values corresponding to the desired deviation. Alternatively, you can of course work with a manual exposure meter.

However, if you want to expose a slide film by a half-stop less, or expose colour negative film more generously, this is very easy. After the correct exposure is confirmed in the viewfinder by the two triangular LEDs, simply stop down the aperture by half a stop. For varying exposure in full-stop increments you can also use the shutter setting control.

Manual exposure mode will probably only be used in exceptional circumstances. After all, both cameras are primarily designed for carefree photography without technical constraint. But if you do want to explore the boundaries, you still have a great deal of scope for experimentation.

# Expert flash system

The integral flash unit of the 3xi in conjunction with the expert flash control system makes flash photography easy. It automatically achieves perfect flash shots in practically all light conditions. This is achieved by using functions like automatic and manual fill-in flash, red-eye reducing flash as well as long exposure flash technology. The small integral flash unit allows shots at night or in very low light, but ensures technically better photographs in a variety of shooting situations, like fill-in flash for backlight. The small integral flash can even provide wireless remote control for the Minolta 3500xi program flash unit, without giving up the convenience of TTL flash control.

In automatic program mode the 3xi automatically activates the small integral flash, or a unit mounted on the camera, whenever required. All the functions of external flash units are identical on the 3xi and SPxi. As soon as the camera determines, depending on subject and light conditions, that additional flash light would improve the end result, the small integral flash unit is popped up, charged and fired on release of the shutter. The same goes for a program flash unit that is mounted and switched on. The flash unit of the 3xi is so cleverly integrated into the camera that it is hardly noticeable at first glance. For its size it is surprisingly powerful, managing a guide number of as much as 12 at ISO $100/21°$ and the angle of coverage is sufficient for a 28mm lens. Thanks to the surprisingly fast recycling time of only 2 seconds, the photographer is ready to shoot again extremely quickly when using fill-in flash. But you don't have to wait until the automatic system of the camera registers a backlight situation or excessive contrast in a subject; you can switch on the fill-in flash function manually at any time by pressing the flash control button on the back of the 3xi. But in this case the button has to remain pressed during the exposure; otherwise, even if it has been popped up, the flash unit will only flash in program mode when the expert exposure system of the camera deems this necessary. In aperture and shutter priority the integral flash unit is only fired if it has been activated manually.

Regardless of the exposure function you select, the shutter of the Minolta 3xi can only be released when the flash unit is fully

charged. Once it has been fired the photographer is informed of correct flash exposure by rapid flashing of the flash symbol in the viewfinder.

If you want the automatic flash function can be deactivated at any time simply by pushing the flash unit down when it is already up. The unit will now remain switched off while you keep the camera on the eye, but as soon as you take it down, the flash will re-appear, provided the expert flash system thinks this is necessary. With the help of the flash control button on the back of the 3xi, the automatic flash function can also be switched off completely.

## Red-eye reduction flash

Flash portraits often suffer from so-called 'red-eye'. This is caused by a reflection of the flash light from the back of the eye. It is particularly noticeable when the flash unit is positioned close to the optical axis. If ambient light levels are very low, the pupils of the eyes dilate and the flash light hits the retina at the back of the eye. But thankfully, the eye can be tricked by using a series of pre-flashes which cause the iris to contract so that the flash is less likely to bounce straight back off the retina. Use this pre-flash function whenever you shoot portraits in badly-lit rooms, although it's not usually needed for fill-in flash where 'red eye' is rare.

The pre-flash function is activated with the pre-flash button next to the data panel. Here, a smaller second flash symbol appears next to the normal flash symbol on the data panel. Switch it off by pressing the button once more. The 3xi can flash with or without pre-flash in all exposure modes.

*Fast zoom lenses with longer focal lengths are advisable for shots from the world of industry.*

## Flash shots with manual preselection of shutter speed and aperture

For maximum creative freedom all shutter speeds of 1/90 sec and slower - including **buLb** - can be used when the camera is set to manual mode. The automatic flash control system of the 3xi will also work without difficulty in this mode. But if you accidentally select too fast a shutter speed in this mode, the camera automatically sets the correct sync speed of 1/90 sec. Slower shutter speeds right down to 30 seconds, on the other hand, are maintained.

On focal plane shutter cameras correct flash exposure is only possible within a limited shutter speed range. This is because focal plane shutter cameras - practically all 35mm SLR cameras - control their shutter speed by means of two curtains which expose the image area for a particular time.

On the 3xi, shutter speeds faster than 1/90sec are not achieved by opening the shutter completely. Instead, a small slit between the first and second shutter curtain scans the film surface, exposing it to light for a short period of time. This means that for the exposure the first shutter curtain starts to move, opening a proportion of the film surface. To give fast shutter speeds, the second shutter curtain starts to finish the exposure before the first one has reached the other end of the frame and uncover the entire image area.

But as the period of time needed by the slit to travel across the image area is much longer than a flash emission, the light will only reach part of the image uncovered during the actual flash emission. This means that only the area uncovered at the moment of the flash exposure is correctly exposed.

*When using shorter focal lengths, you need to ensure that the dominant foreground is taken into account.*

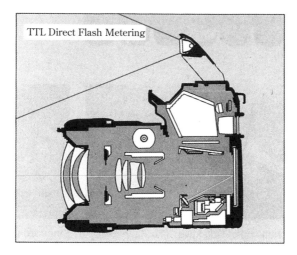

The integral flash unit of the 3xi is switched on automatically in low light. Its coverage angle completely illuminates the angle of view of a 28mm lens.

Things are completely different with slower shutter speeds. Here, the first shutter curtain opens the image completely and the second covers it up only after the exposure has taken place. In this case the flash unit can illuminate the entire image area, usually immediately after the shutter is fully open. This allows you to combine ambient and flash illumination.

## Slow shutter sync with the SPxi

Slower flash sync speeds can be achieved by metering the subject background. Take this approach whenever the atmosphere of a room or nocturnal surroundings provide the mood of a shot and the flash merely illuminates only a detail in the foreground. To do this, aim the spot metering circle in the viewfinder of the SPxi at the subject detail and press the spot metering button to lock in the measurement. Obtain the long exposure in this way and it is maintained even during flashing, provided the spot metering button remains pressed when the shutter is released. The camera then correctly exposes the surroundings using a relatively slow shutter speed, and reduces the flash exposure so that only the main subject

in the foreground is correctly lit. In this way destroying the mood is avoided. The camera is programmed to take account of the fact that the background of such a shot needs to be slightly underexposed and so no corrections are necessary. Slow shutter sync prevents the subject background from merging into blackness like it does with faster shutter speeds. You don't need to worry about camera shake too much as the short burst of flash gives a sharp main subject. But if the background must be sharp, you need to use a tripod.

In such situations a very bright background, or using a wide aperture, may mean that the flash sync speed is limited to 1/90 sec, as the background might be overexposed. With slow shutter sync, too, the correct flash exposure is indicated by fast flashing of the flash symbols in the viewfinder.

## Wireless remote flash control of the 3xi and the Minolta 3500xi program flash unit

Apart from the pre-flash function, all flash techniques described so far can be carried out either with the integral flash unit of the 3xi, or on both cameras with an i or xi series Minolta program flash unit. Used in conjunction with the Minolta 3500xi program flash unit, the 3xi offers the additional option of wireless remote flash control. This always ensures accurately exposed flash shots, regardless of which exposure function the flash unit is used, even when it isn't connected to the camera.

To program the 3xi to wireless remote control of the flash unit, you need to set the channel selector switch inside the flashgun's battery chamber to **CH1**, then mount it on the camera and switch it on. The remote flash control function can now be selected with the shutter setting control as you hold down the flash control button. As the double flash symbol starts flashing on the data panel and the letters **ON** appear, the function is activated. In addition, the wireless lens on the rear of the flash will light. The off-camera flash unit is simply fired using the integral flash unit of the 3xi and can now be removed and positioned independently. To ensure that the external flash unit can recognize the control signals, it mustn't be obscured by the subject.

Start signal from 3xi.

The 3500xi starts firing.

The Dynax 3xi sends a stop signal when TTL metering detects sufficient exposure has occured at the film plane.

The integral flash unit of the Minolta 3xi allows wireless remote control of the Minolta 3500xi program flash unit. Flash exposure metering is carried out automatically through the lens.

The external flash unit's AF illuminator flashes repeatedly to indicate full charge and that it's ready to fire. When the integral unit is also ready, the single and double flash symbol will flash alternately in the viewfinder. Fire a test flash from the external flash unit, if you like, by pressing the pre-flash button. The camera's integral flash will fire and a fraction of a second later the external unit will respond with a flash. Doing this ensures that the off camera unit is within range and will respond correctly to subsequent control flashes.

The shutter can be released as soon as both units are once again fully charged and the integral flash unit will once again send the start signal. The 3500xi will start to illuminate the subject with a rapid series of light impulses. When the direct TTL metering system of the camera registers that sufficient light has reached the film surface, the integral flash unit of the 3xi emits a second light signal to shut off the 3500xi.

In this mode the off-camera flash always fires, even in automatic program mode, regardless of whether or not the ambient light would be sufficient for an exposure without flash. The fastest flash sync speed is reduced to 1/45 sec.

The 3xi allows wireless remote control of the Minolta 3500xi program flash unit. The latter has an AF illuminator to support the autofocus function in low light. The coverage angle of the power zoom reflector is automatically adjusted to the angle of view of the lens. If you are using wireless remote control, the zoom reflector has to be set manually.

To achieve a more three-dimensional lighting effect, the external and integral flash unit can also illuminate the subject at different light intensities, at a ratio of 2:1. To achieve this, just hold down the flash control button during the exposure, and roughly one-third of the light reaching the subject comes from the integral flash unit, and the remaining two-thirds comes from the more powerful off-camera flashgun.

The easiest way to switch off the remote flash control function is to press the program reset button. Alternatively, you can re-mount the flash unit on the camera, hold the flash control button down and select the **OFF** indication on the data panel with the shutter setting control.

With wireless remote control of the Minolta 3500xi program flash unit, the illumination angle of the zoom reflector must be set manually. The Minolta 3500xi program flash unit can also be used on the 3xi or SPxi as a normal on-camera flash sporting a guide number of 35. In this case the flash reflector is automatically adjusted to the selected focal length on the lens in the range between 28mm and 105mm.

Off-camera flashing allows effective lighting techniques familiar from professional shots. It can produce attractive flash effects and

better lighting, particularly in the close-up range, not only with still life shots or portraits, but also for interior shots.

The instruction manual claims slight restrictions in terms of distance and functioning - for reasons of product liability. It says, for example, that in such instances the ambient light should be kept as low as possible. But as the integral flash unit has a substantially greater range than Minolta indicate; it can fire the 3500xi program flash unit across a distance of up to 5 metres without any problems in normal light conditions. But the farther away it is from the subject, the more important it is for the additional flash unit to receive the firing signal directly. And the test facility should always be used to confirm that the system will work.

## Automatic power zoom reflector

As with the Minolta 3200i and 5200i program flash units, the 3500xi also automatically adjusts its flash reflector to match the focal length selected. When the flash unit is mounted on the camera, the reflector is set to the correct value as soon as the autozoom control system preselects a focal length. If this focal length lies between 28mm and 105mm, the power zoom reflector automatically matches this setting, using data transmitted via the hot shoe contacts.

Apart from providing more even illumination, higher guide numbers and hence greater coverage can be achieved when shooting telephoto subjects, since the light is concentrated. In the close-up range, on the other hand, guide numbers and coverage sometimes need to be reduced, and so the 3500xi is equipped with a **Low** button for reducing the flash output. Hand in hand goes a reduction in flash recycling time of almost a half, and this drastically cuts down energy consumption. For special applications, or in remote control mode, the reflector can be adjusted manually to 28mm, 50mm or 105mm focal length settings.

## Bounce flash

The flash reflector can be tilted upwards from its standard position by up to 90°, or set at 45°, 60°, and 75° in between. This allows the photographer to point the flash at suitable nearby reflective sur-

faces, like ceilings or white walls to achieve soft, indirect lighting without the harsh shadows of direct flash. Bounce flash is suitable for many subjects, but is especially good for portraits. Never aim the flash at coloured surfaces for indirect flashing, as this will also be reflected and you will end up wondering where that seemingly inexplicable colour cast came from. On the other hand, it may be a good way of warming up a portrait.

## AF illuminator

The integral autofocus illuminator also needs power, if only a little. It automatically fires infrared flashes to help the autofocus system with subjects that have little contrast and are dark. In complete darkness its range is approximately 9 metres.

---

### Guide number and output

Guide numbers (in metres and at ISO 100/21°)

| Coverage | 28mm | 35mm | 50mm | 80mm | 105mm |
|---|---|---|---|---|---|
| **Output** | | | | | |
| Output NORMAL | 22 | 26 | 29 | 33 | 35 |
| Output LOW | 5.5 | 6.5 | 7.3 | 8.3 | 8.8 |

Range 0.7m to 21m (at ISO 100/21° and 50mm,f/1.4)

---

The Minolta 3500xi program flash unit can also be used with the 7000i and 8000i series Minolta cameras, although the remote control function is not available. Used in conjunction with the 9000, 7000 and 5000 models, the automatic flash function in program mode is not available either.

## Program flash unit 2000xi

The Minolta 2000xi program flash unit is specifically designed for the SPxi, but can be used on all other Dynax cameras, which don't have an integral flash unit. It is particularly light and compact and will even light the angle of view of a 28mm wide-angle lens when a diffuser is attached. Despite its tiny dimensions and its 140g weight, it has a respectable guide number of 20. When the flash is used with the wide-angle attachment, the guide number drops to 16. This is substantially more light than the integral flash unit of the 3xi provides. In addition, the unit has an AF illuminator which allows automatic focusing even in darkness. The camera automatically activates it in low light conditions or subject contrast. When the unit is switched on, its functions are the same as those of the integral flash unit of the 3xi, except that remote flash control is not

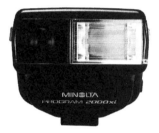

The Minolta 2000xi program flash unit weighs only 140g and has a guide number of 20. With the diffuser attached, it illuminates the angle of view of a 28mm wide-angle lens.

possible. A set of four fresh 1.5-volt AA batteries last for between 300 and 5000 flashes, depending on the flash output used. Depending on the charging state of the batteries and the ambient temperature, the flash recycling times are between 0.5sec and 4 seconds, allowing relatively fast sequence shooting with flash light. At ISO 100/21° and with a 50mm,f/1.4 lens the flash range is a maximum of 14 metres. According to the data given by Minolta, the coverage is only 9 metres under the same conditions. But the coverage does depend on the ambient light, and experience has shown that 14 metres can frequently be achieved. However, these are all just meaningless figures, as most flash subjects are usually at much closer range. Attempts to take flash shots from the seating in football stadia or sports halls are unlikely to yield acceptable results, even when powerful equipment is used.

## Photography with the Minolta 5200i and 3200i program flash units

The 3200i and 5200i program flash units can be used on the 3xi or SPxi with a few restrictions. To be sure flash units and camera are switched to automatic program flash, you simply press the program reset button when the flash unit is mounted. Normally you will not need to make any settings on the flash unit itself, except using the **ON/OFF** button if you do not want flash. The 3200i also has the reduced output button.

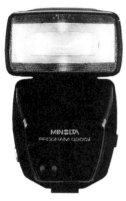

The Minolta 5200i program flash unit, with a guide number of 42, is a top-flight unit for professional requirements. It offers special functions like strobe flash and ratio control when several flash units are used together.

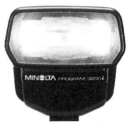

The 3200i program flash unit has a guide number of 32. The zoom reflector automatically adjusts to the lens focal length.

The powerful Minolta 5200i program flash, however, has quite a few other buttons, which suggests that it has been equipped with many unusual features. It has a **Menu** button in the bottom row, between the **ON/OFF** and **TEST** buttons. This allows the photographer to switch between two levels of functions. The top row of four grey rubber buttons allows the control or correction of a variety of functions. The left-hand button (**LIGHT/MULTI**) switches on the indicator panel illumination and is also responsible for activating the strobe function for sequence flashing and slow shutter sync. The **TTL-M/FREQ** button next to it is used to switch between automatic and manual mode, as well as for selecting the

strobe flash frequency of 50, 30, 10, 5, 3, 2 or 1Hz. The third button (**ZOOM/REPS**) is for the power zoom adjustment and selecting the number of sequence flashes of 10, 7, 5, 4, 3, 2, or an unlimited number. The **LEVEL/RATIO** button for output control (1/1, 1/2, 1/4, 1/8 1/16 or 1/32) is on the extreme right. It is also used to control the relative output if several flash units are used, which are in this case connected by cables.

All relevant data for the flash exposure is indicated on the LCD panel of the flash unit. But if you prefer your distance data in feet, you can switch from metric to imperial measures by operating a switch in the battery chamber.

The 5200i program flash unit has a guide number of 42 at ISO 100/21° with a focal length of 50mm. Its range is up to 30m with a 50mm,f/1.4 lens. Four AA alkaline-manganese batteries, or four 1.2-volt Ni-Cd rechargeable batteries of the same size allowing between 100 and 3500 flashes at a rate of between 0.2 and 11 sec, depending on the shooting distance and prevailing ambient light. The unit also has a socket where the external battery pack, available as an accessory, can be connected.

The autofocus illuminator helps the AF system of the 3xi or SPxi with low subject contrast or in darkness.

The reflector of the 5200i program flash unit has an internal power zoom which automatically adjusts its angle of coverage to suit the focal length of the lens. The zoom reflector automatically adjusts to match the angle of view of lenses with focal lengths between 24mm and 85mm. You can, of course, use flash with longer focal lengths, but you will then be 'wasting' light.

The guide number and so the maximum range of the flash unit alters as the angle of coverage is changed. It is 24 at 28mm focal length, 32 at 28mm, 36 at 35mm, 42 at 50mm and 52 at 85mm. These guide numbers apply with an ISO 100/21° film.

But more important than these guide numbers is the option of manually adjusting the angle of coverage to 24mm, 28mm, 35mm, 50mm, 70mm and 85mm. This is handy for bounce flash, if light is to be reflected off a ceiling to achieve softer shadows. Best results are obtained if the reflector is set to cover a shorter focal length than is actually used on the lens. This ensures that the subject is covered completely by the bounce flash light, and will create the softest possible shadows. Practical experience proves that setting the

reflector to a setting some two focal length values wider than the lens works well. The reflector can be tilted upwards and to the right by 90° respectively, and to the left by 180°.

The 5200i has an accessory socket for connecting a second i series flash unit. The **RATIO** function allows the flash output of the two units to be automatically controlled at a ratio of 1:2 or 2:1. With the relevant accessories (Triple Connector TC-1000) up to three i series units can be controlled with the ratio control function.

## Macro Flash 1200AF Set N

The Minolta Macro Flash 1200AF Set N makes close-up flash photography with the 3xi and SPxi easier. The Macro Flash 1200AF Set N is technically identical to the Macro Flash 1200AF, available for the Minolta 7000. But its advantage, apart from fully-automatic TTL flash control, is its extreme compactness.

The four flash tubes, arranged in a square around the optical axis, can be individually switched on and off, to allow different lighting effects to be created. The flash consists of two main components: the flash head and the control unit which is attached to the accessory shoe via the Flash Shoe Adapter FS-1100, like any other flash unit. The flash head fits via a special adapter ring to the filter thread of either the 50mm,f/2.8 or 100mm,f/2.8 macro lenses. The flash head can be rotated around the lens to gain the best possible illumination.

To make focusing easier, there is a focusing lamp at each corner of the flash head. These also help you compose if the lighting conditions are poor and are automatically extinguished when the shutter release button is lightly pressed or has not been touched for 30 seconds. During the exposure they are also switched off and they can be manually by extinguished using a button at the rear of the control unit.

Automatic flash metering is controlled by TTL flash control. Flash-ready and correct flash exposure are indicated in the viewfinder. Flash-readiness, and confirmation that the flash exposure was sufficient, are also indicated on the back of the control unit. The correct aperture settings for various reproduction ratios may be read off the table at the back of the control unit.

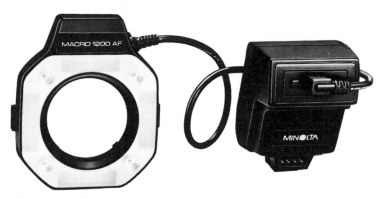

Minolta Macro Flash 1200AF Set N

The Macro Flash 1200AF Set N has a guide number of 12 at ISO 100/21° with all four flash tubes switched on. The power supply is by four 1.5-volt AA-size or appropriate rechargeable batteries. For continuous operation there is a power unit that can be plugged directly into the mains.

To save energy, the flash will automatically switch itself off if the release has not been activated after approximately one minute, but recharging begins as soon as the shutter release is pressed.

# Interchangeable autofocus lenses

You need the right lens on the right camera to make the most of your equipment. This applies more than ever to the 3xi and SPxi: Minolta's new ASZ function, the auto stand-by zoom, can only be fully utilized if both camera and lens are perfectly tuned to work together. Lenses help us to see and to make creative use of what we see. They allow us to make subjective use of perspective, to change the relative size of things, and therefore to turn visual ideas into pictures.

The new xi lenses with their popular focal length ranges are matched to the 3xi and SPxi. Each of these small, compact zoom lenses turns camera and lens into a photographic system whose 'intelligently' controlled automation goes beyond focusing and exposure to include focal length control.

## Why interchangeable lenses?

The creative possibilities of an SLR camera can only be fully realized with interchangeable lenses. Using different focal lengths allows you to alter framing without changing your shooting position.

Lenses are grouped into roughly five categories depending on their focal length and special characteristics: wide-angle, standard, telephoto, macro and zoom lenses. Wide-angle lenses are all those whose focal length is 35mm or less. These lenses have a wide angle of view and allow shots of large subjects at short distances. The shorter their focal length, the wider their angle of view. The so-called fisheye lenses are a special group within this category and have an angle of view of 180°. However, fisheye lenses are characterized by pronounced barrel-shaped distortion. This means that all lines not running through the centre of the image are reproduced as curved lines.

Standard lenses have focal lengths of around 50mm. Their angle of view of approximately 45° corresponds to the perception of the human eye.

AF-Macro 100mm,f/2.8

AF-Macro 50mm,f/2.8

AF 135mm,f/2.8

AF 35-80mm,f/4-5.6

AF 35-105mm,f/3.5-4.5

AF 70-210mm,f/3.5-4.5

AF 80-200mm,f/4.5-5.6

AF-Apo 80-200mm,f/2.8

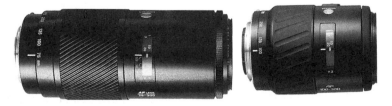
AF 75-300mm,f/4.5-5.6

AF 100-300mm,f/4.5-5.6

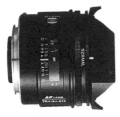
AF-Fisheye 16mm,f/2.8

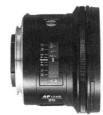
AF 20mm,f/2.8

AF 24mm,f/2.8

AF 28mm,f/2

AF 35mm,f/1.4

AF 50mm,f/1.4

AF 85mm,f/1.4

AF 100mm,f/2

AF 24-50mm,f/4

AF 28-85mm,f/3.5-4.5

AF 28-135mm,f/4-4.5

Wide-angle lenses emphasize the foreground. Photo: R. Hagenauer

The telephoto category starts from around 80mm. Telephoto focal lengths allow frame-filling shots of subjects from a greater distance.

Macro lenses, on the other hand, are available in various focal length ranges. Macro lenses with focal lengths of 50mm and 100mm are available for the Minolta Maxxum/Dynax cameras. They are specialist lenses for photographing at close range and allow you to capture frame-filling images of small and tiny subjects at a reproduction ratio of up to 1:1.

Zoom lenses have variable focal lengths and can be continuously adjusted to suit the situation within a given range. In recent years enormous progress has been made in the design of zoom lenses. Not only have they become smaller and lighter, but their optical qualities are now comparable to fixed focal lengths. They are therefore amongst the most popular interchangeable lenses and Minolta has developed five new zoom lenses with different focal length ranges specifically for the xi generation cameras. The auto stand-by function of the Minolta 3xi and SPxi only works with these lenses.

## Reproduction ratio and perspective

Shooting distance and focal length determine how large a subject will be reproduced on the film. The relationship between subject size and image size is called the reproduction ratio. It makes no difference to the reproduction ratio whether a subject is photographed with a long focal length at a great distance, or with a short focal length at close range. By changing his shooting position, the photographer can use different focal lengths to capture a subject at exactly the same size. But shots of a subject taken from different distances remain fundamentally different.

A change in the shooting position is automatically accompanied by a change in the perspective. Perspective governs how the relative sizes of objects, set at different distances from the camera within a three-dimensional space, are reproduced on the two-dimensional photograph. If the distance between the subject and

The appeal of this shot lies in the graphic structure of this simple subject.
Photo: R. Hagenauer

camera changes, the relative sizes of objects at different distances from the camera also change. Perspective therefore doesn't depend on the focal length, only on the reproduction ratio.

If there were no limits to enlarging negatives, telephoto shots would not require long focal lengths, we would simply enlarge a small subject in the wide-angle shot to the desired reproduction ratio. It would have the same perspective as a telephoto shot from the same shooting position. The shorter the shooting distance, the more obvious the change in relative sizes will be in the shot.

## The xi autozoom lenses

A lot has been changed on the new Minolta autozoom lenses compared to conventional zooms. Take, for example, the ergonomically designed, non-slip zoom ring on the lens barrel, which does away with the need for separate controls for focal length and focus setting. But a lot has changed in electronic terms, too.

Although earlier Minolta lenses were equipped with a ROM-IC, a read-only memory, the new lenses have been upgraded and have their own 8-bit microcomputer which constantly exchanges data with the camera computer. Each of these new lenses also has its own zoom motor. In conjunction with the new 3xi and SPxi, these new developments enable the lenses to offer an auto stand-by zoom function which is not available on the 12 earlier zoom lenses. These are still in the Minolta range and can be used on the 3xi and SPxi without any loss of functions.

But not all the new functions of the xi lenses can be used with the 3xi and SPxi - if you want to utilize the image size lock function or the wide view function you have to go for the top model, the 7xi.

Zoom lenses allow the continuous adjustment of the focal length within a certain range. They can be used to change the framing, and therefore the reproduction ratio, without any change in the shooting position. Until now, this adjustment was made manually by the photographer, and we were always advised to start with the longest focal length for focusing whenever possible. The experienced photographer only selected the optimum framing after focusing at the longest focal length.

But fuzzy logic control brings innovation in this area, too, as the autofocus system feeds the subject distance to the auto stand-by

AF-xi 28-80mm,f/4-5.6

AF-xi 80-200mm,f/4.5-5.6 - Macro

AF-xi 280105mm,f/3.5-4.5

AF-xi 100-300mm,f/4.5-5.6 - Macro

AF-xi 35-200mm,f/4.5-5.6

Used with the Minolta xi zoom lenses, the Minolta xi cameras offer auto stand-by zoom.

zoom as soon as the sensor on the viewfinder eyepiece has activated the 3xi and SPxi. On the basis of this data, the ASZ program selects a focal length setting which ensures a balance between main subject and surroundings. But as photography is also supposed to be a creative activity, the Minolta xi lenses are able to respond to the photographer's own ideas at lightning speed. This applies to manual motorized zooming as well as manual focusing also changed via the zoom motor.

For manual motor zooming the zoom ring can be turned to the right and left by up to 5°, and the zoom speed changes in proportion to the degree of the turn. This means that fast changes in focal length can be carried out with the same ease as precise fine-tuning.

The focal length is changed more quickly, the further the ring is turned one way or the other. Although this takes some getting used to, it quickly proves a lot more convenient than the turning and pushing we've been used to.

For manual motor focusing, the non-slip focal length and focus ring is simply pulled towards the camera and turned slightly in the desired direction. As with the motor zoom, the setting speed of the focus motor varies with the degree of the turn. So you can either focus very quickly or set the focus very slowly and precisely. The final autofocus setting can easily be held and confirmed by simply pulling the zoom ring towards the camera, and uncoupling the autofocus system.

The new lenses combine surprisingly wide focal length ranges with compact design. So far, five lenses are available:

AF Zoom xi 28-80mm,f/4-5.6
AF Zoom xi 28-105mm,f/3.5-4.5
AF Zoom xi 35-200mm,f/4.5-5.6
AF Zoom xi 80-200mm,f/4.5-5.6 Macro
AF Zoom xi 100-300mm,f/4.5-5.6 Macro

These light, easily handled lenses fulfil the most varied requirements, so every photographer should be able to find a 'favourite' amongst them. In addition, all the xi lenses can achieve surprisingly large reproduction ratios, so that macro lenses are often superfluous even for shots of small subjects.

*Telephoto lenses with focal lengths between 80mm and 135mm are ideal for detail shots of buildings. (pages 87, 88 and 89)*

## AF Zoom xi 28-105mm,f/3.5-4.5 and AF Zoom xi 35-200mm,f/4.5-5.6

The two new lenses AF Zoom xi 28-105mm,f/3.5-4.5 and AF Zoom xi 35-200mm,f/4.5-5.6 are varifocal designs with rear element focusing. Both lenses use an aspherical composite lens. The compact construction of both lenses owes much to the use of the unusual electronic focus compensation method. Unlike conventional zoom lenses, where the focus is kept constant during focal length adjustment using mechanical couplings, the focus is adjusted electronically on these lenses. During focal length adjustment the autofocus motor of the camera simultaneously tracks the focus.

Thanks to their wide zoom range and large reproduction ratios, these two lenses can be used for a multitude of applications, ranging from close-up shots to sport or landscape photography.

While the 28-105mm xi lens offers a speed of f/3.5 at 28mm focal length and f/4.5 at 105mm, the wider focal length range of the 35-200mm xi lens costs a whole aperture stop in speed. You'll hardly miss this aperture stop if you always take photographs in relatively good weather, but if you like unusual moody lighting, you'll appreciate the extra aperture stop.

At 450g and 500g respectively, the difference in weight between the two lenses is substantially less than the different number of elements in their optical construction suggests - 13 elements in 10 groups, and 17 lenses in 15 groups on the longer focal length. The maximum reproduction ratio, too, is worth noting - it's 0.1 on the 28-105mm lens, and as much as 0.16 on the 35-200mm. The closest focusing distance of both lenses depends on the focal length and changes continuously from 50cm in the wide-angle setting to 100cm at the maximum telephoto focal length.

*Graffiti is always a popular subject among photographers. As it is not always easily accessible, telephoto or zoom lenses are advised.*

## AF Zoom xi 100-300mm,f/4.5-5.6 Macro and AF Zoom xi 80-200mm,f/4.6-5.6 Macro

If you need medium to longer focal lengths, these light and compact lenses are your best choice. Both offer extremely easy handling and are ideal for snapshot, sports and travel photography. The AF 100-300mm xi not only has a 3x focal length range, it can also capture small subjects at almost 1/4 of their original size.

At 440g, the 100-300mm lens is exactly 140g heavier than the 80-200mm. Despite the difference of 11 elements in 9 groups on the longer focal length lens and 9 elements in 9 groups on the 80-200mm, the design differences are surprisingly slight and even extends to their identical close focusing distance of 1.5m. The smaller focal length range of the 80-200mm lens means that it is some 2cm shorter. At exactly 8cm, it is amazingly compact and is set to become one of the most popular lenses in the xi autozoom range.

## AF Zoom xi 28-80mm,f/4.5-5.6

The AF Zoom xi 28-80mm,f/4.5-5.6 is certainly a special optic. Minolta expects that its compact (67mm long) and light (275g) construction, as well as its popular focal length range, will make it the 'standard autozoom lens' for many photographers. An aspheric

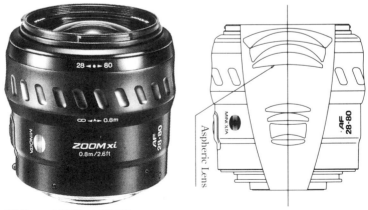

AF-Zoom xi 28-80mm,f/4-5.6

composite lens contributes to the compact optical design of 7 elements in 7 groups. The lens allows close-up shots down to 1:10 and a close focusing distance of 0.8m. A zoom range from wide-angle to medium telephoto and is therefore ideal for many types of subjects, from landscapes, via groups, to portraits.

The relatively slow speed of lenses in this range means that conventional fixed focal length lenses have not become superfluous. The opposite is more likely to be the case. If you are a fan of extreme sharpness and slow film, you are bound to find the right fixed focal length in the Minolta AF lens range. The difference in speed at 80mm between f/5.6 on a zoom and f/1.4 on a fixed focal length is three full aperture stops. To achieve the same shutter speed in critical light conditions you can use a film speed of ISO 50/18° with f/1.4, when you would need ISO 400 for the f/5.6 zoom.

## Power Zoom lens

Like the new Minolta xi lenses, whose design it follows, the cheaper Minolta AF Power Zoom 35-80mm, f/4-5.6 Macro also offers motorized focal length adjustment. The focal length is also selected via the large ring on the lens barrel, and the focal length adjustment speed is variable. The further the non-slip ring is turned, the faster the motor works. The ring can be turned by approximately 5° for focusing and about 15° for focal length adjustment. If you let go of the ring, it automatically returns to its original position.

The focal length adjustment and manual focusing are not, however, carried out by a motor integrated into the lens. As soon as you turn the zoom ring, a coupling system diverts the power of the autofocus motor in the camera from the AF system to focal length adjustment or manual focusing. This approach allows the weight of the lens to be reduced, despite motorized power. A further reduction in weight was achieved by the special optical construction, which includes two aspherical elements. The zoom weighs just 175g. Eight individual elements were used in its optical construction and its closest focusing distance is 0.5 metres. The auto stand-by zoom function is not available on this lens.

One feature that can often be quite useful is the ability to stop autofocusing, to lock it and correct it. It is possible to stop the AF setting without switching to manual focus mode, by simply pulling

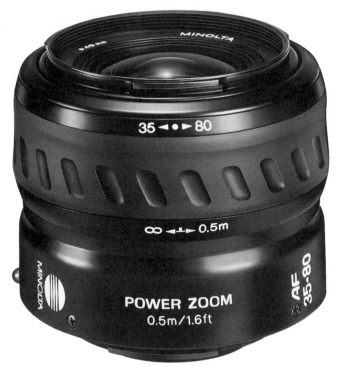

The Minolta AF Power Zoom lens offers motorized focal length adjustment, but not the stand-by zoom function.

back the zoom ring and correct it, when necessary, by manually by turning the focus ring. As soon as you let go, the camera will automatically switch back to automatic focusing. If you don't want it to do so, you need to push the AF/M switch-set at the bottom next to the camera bayonet - in order to switch to manual focusing.

## AF zoom lenses

Apart from the above-mentioned five new autozoom lenses developed specifically for the xi generation, Minolta offers a further 12 zoom lenses with various focal length ranges. It is possible that a few of these lenses could be replaced by new designs at some point in the future, in order to give the camera owner full access to the convenience and technical possibilities of the xi series.

**AF 24-50mm,f/4** - The Minolta AF 24-50mm,f/4 wide-angle zoom is a real reporter's lens for shots in the heart of the action at fun fairs, festivals, in marquees or interiors. It is ideal for landscape shots or architectural photography. The relatively high speed of f/4 ensures a reasonable flash range in poor lighting conditions. Like many of the Minolta zoom designs, this particularly compact zoom contains an aspherical composite lens, which allows faster focusing as well as delivering a good optical performance. At just 60mm long and weighing 285g, you can take it anywhere so it is ideal for the travel photographer. The filter size is 55mm.

**AF 28-85mm,f/3.5-4.5** - This Minolta lens covers a more than 3x focal length range, from wide-angle to portrait telephoto. It is excellent for interior shots and is ideal for photojournalism, snapshots at fun fairs or similar events, where it can cope with group shots through to frame-filling portraits. It's relatively fast and allows quick snapshots as well as good flash coverage ranges with medium to fast films.

**Dynax 35-80mm,f/4-5.6** - This small and light lens with integral front element protection has a focal length range of 35-80mm, covering more than half of all average photographic situations. The range of this universal lens is sufficient for group shots and frame-filling portraits, landscapes and snapshots of children playing in the distance. Close-up, the lens can achieve a maximum reproduction ratio of 1:6.

The integral front element protector keeps the lens safe from dirt, dust and scratches. It speeds up lens changes and prevents accidental fingerprints, finally putting an end to the search for the lens cap.

The slide switch on the side ensures fast opening and closing, the two slats of the protector simply move up or down rather like a cigar-cutter, and the cover behind which the two slats disappear doubles as an effective stray light hood. The filter size is an extremely small 46mm. As the front element turns during focusing, a special filter holder is needed to hold polarizing or other effect filters in place during focusing.

The focal length is changed with a wide, non-slip rubber-coated ring. For manual focusing, however, the photographer has to make do with a fairly narrow focusing ring without the non-slip coating but this is only intended for occasional use anyway.

It is likely that this lens will be removed from the Minolta range, to be replaced by the new Power Zoom with identical speed and focal length range.

**Dynax 35-105mm,f/3.5-4.5** - Despite its faster speed and wider focal length range, the Minolta AF 35-105mm,f/3.5-4.5 is only 1.5mm longer and 3mm wider than the 35-80mm lens. The difference in weight is just 95g.

This lens, too, has an aspherical composite lens, which allows it to be so compact. Its 3x focal length range and relatively high speed make it a versatile, universal lens, with an additional close-up setting. The closest focusing distance is just 85cm, allowing close-up shots with a reproduction ratio of 1:6.

**Dynax 70-210mm,f/3.5-4.5** - Despite its 3x focal length range, this telezoom is relatively fast, allowing action-stopping shutter speeds with medium speed films even on overcast days. It weighs just 420g and is only 10cm long.

It has a special autofocus control button which causes Maxxum/Dynax series cameras to stop the focusing process to allow the shutter to be released straight away, suspending the camera's focus priority function. Other functions of the AF control button cannot be accessed with the 3xi or SPxi.

The filter size is 55mm, and the focal length ring is fitted with a non-slip rubber coating. The closest focusing distance is 1.1m.

**Dynax 80-200mm,f/4.5-5.6** - This zoom lens with the classical focal length range of 80-200mm, already has a counterpart amongst

the new xi lenses. It is an ideal complement to the 35-80mm zoom and shares a similar construction and the same integral front element protector. With a weight of just 300g and a length of 78mm it falls into the category of small, light lenses. It also has a small filter size of only 46mm and works in the double telezoom system, which allows particularly fast automatic focusing. Its low weight and compact design make it an ideal lens for travel photography. The closest focusing distance of 1.5m allows frame-filling shots of relatively small subjects. The maximum reproduction ratio of this lens is a useful 1:4.

**AF 80-200mm,f/2.8 Apo** - The AF 80-200mm Apo zoom is a heavyweight, but a real optical treat. Its extremely high speed and a special element made of AD glass which suppresses chromatic aberration gives this high performance lens a special place amongst zoom lenses. Its expensive construction comprises 16 elements in 4 groups, which adds to the weight of this fast giant. If you want to enjoy the benefits of the high reproduction quality of this lens, you have to be prepared to carry around 1350g, not to mention the high financial outlay need to acquire it in the first place.

**AF 75-300mm,f/4.5-5.6** - Minolta's well-proven 75-300mm telezoom has an initial focal length that is 25mm shorter than the new 100-300mm zoom. It is the ideal lens for sports or animal photography. The expensive construction comprises 13 elements in 11 groups, making it more than twice as heavy and over 6cm longer than the new 100-300mm zoom. A special feature is the switch on the lens barrel which allows the focusing range to be limited. This switch offers two positions, one for the close-up range from 1.5m to 3m, and another from 4m to infinity. This increases the autofocusing speed for sports, animal or action shots as the lens never has to travel over the whole focusing range.

**Dynax 100-300mm,f/4.5-5.6** - Sports, animal and landscape shots are the strength of this telezoom with a 3x focal length range. Thanks to its sophisticated double telezoom construction, it manages to be the same length as the 70-210mm zoom, and even 10g lighter. Like the 70-210mm, it sports the new autofocus control button which suspends the focus priority of the camera. Its filter

size is 55mm, and a closest focusing distance of 1.5m provides a maximum reproduction ratio of approximately 1:4.

Thanks to its extremely compact construction and low weight, this lens is an ideal companion especially when travelling. Used with the 35-105mm zoom, it replaces a range of five fixed focal length lenses - 100mm, 135mm, 180mm, 200mm and 300mm.

## Wide-angle lenses

**AF 16mm,f/2.8 Fisheye** - This lens has an extremely wide angle of view of 180° in the diagonal and unlike most other fisheye lenses, it fills the entire film format. The closest focusing distance of this 400g lens is 20cm.

The extreme angle of view and the altered perspective (which does not correspond to the normal geometric perspective) do, however, lead to strong barrel-shaped distortion. This means that all lines not running through the centre of the image are reproduced as curved to a greater or lesser extent.

Such a peculiar perspective allows the photographer to create surprising effects, but fisheyes should be used sparingly as they can quickly become tiresome. They are best suited for landscape photography and interior shots.

One feature of this lens are the four revolving integral filters, which move into position just by turning a ring and are fully integrated into the optical construction. This means that a filter has to be used all the time, which explains why one of them is colourless. The other three are orange (for black-and-white and infrared shots), pale pink (for colour shots in fluorescent light) and blue (for colour shots with tungsten light).

**AF 20mm,f/2.8** - This extreme wide-angle lens has an angle of view of 94°, and its plentiful depth of field makes it a versatile choice for use in architectural and landscape photography, as well as photojournalism. It also comes into its own for tight interior shots.

As focusing takes place using the rear element, reproduction in the close-up range is optimized, and the speed of automatic focusing is increased. The lens hood supplied with the lens can be

inverted for transport purposes and the closest focusing distance is 25cm. The expensive optical construction of this fast 285g super wide-angle lens comprises 10 elements in 9 groups.

**AF 24mm,f/2.8** - This compact and light 24mm lens has a slightly more moderate angle of view of 84°. It is ideal for photojournalism and snapshots, useful for landscape and architectural photography as well as tight interiors. When it comes to picture composition, particular care should be taken with the foreground, the lower third of the shot. The closest focusing distance is 30cm, and at just 215g this relatively fast lens is a real lightweight.

**AF 28mm,f/2** - The Minolta AF 28mm,f/2 is suitable for wide-angle shots in low light, such as in twilight or poorly lit interiors. The angle of view of this particularly fast 285g lens is 75°, and its optical construction comprises 9 elements in 9 groups. Its closest focusing distance is 30cm.

**AF 28mm,f/2.8** - This 28mm AF lens is a whole 100g lighter and 7mm shorter, but is also one aperture stop slower than the previous one. It is used for the same purposes as the more expensive and faster wide-angle stable-mate, although it's naturally less useful for available-light photography, when you want to take atmospheric shots without flash. Travel photographers, to whom every extra gram matters, will probably go for the AF 28mm,f/2.8 lens, which weighs just 185g. Landscapes, interiors and snapshots at close range are the strengths of this universal focal length.

**AF 35mm,f/1.4** - The AF 35mm,f/1.4 wide-angle offers an extremely high speed, normally only available on standard 50mm lenses. It is an ideal standard lens, particularly suitable for grabbing atmospheric landscape shots in twilight, or for shots without flash in poorly lit interiors. Its expensive optical construction of 10 elements in 8 groups make this lens relatively heavy and in fact at 470g it is the heaviest wide-angle in the Minolta AF range. Like the AF 28mm,f/2, the AF 35mm,f/1.4 also has a 'floating element' included in its construction to improve close-up quality. The AF 35mm,f/1.4 also has an aspherical lens in its rear element focusing system, which increases its optical quality and reduces focusing time.

The curved rendering of vertical lines in the photograph is typical of shots taken with fisheye lenses. Photo: R. Hagenauer

100

**AF 35mm,f/2** - The AF 35mm,f/2 has a maximum aperture of one stop less than the super-fast AF 35mm,f/1.4. This lens, weighing less than 250g, is almost ideal if you don't work in extremely demanding conditions, such as shooting without flash in even the poorest light conditions. Like its faster 35mm counterpart, this lens also offers excellent field flatness, For many photographers weight is a decisive factor, and the reduction in speed by one stop reduces the weight by almost half. Filter thread and closest focusing distance are identical with the faster 35mm wide-angle, namely 55mm and 30cm respectively.

## Standard lenses

**AF 50mm,f/1.4** - Standard lenses are sadly becoming increasingly unfashionable. These versatile lenses are usually particularly fast, and their angle of view roughly corresponds to that of the human eye. This means that many photographers find standard lenses with focal lengths around 50mm boring, but there are not many lenses which offer more possibilities than the much-maligned 'normal' or 'standard' lenses. Their speed and compactness makes them especially suitable for available light photography without flash. Conversely, their wide maximum apertures provide great flash ranges. The fast standard lens with an initial aperture of f/1.4 even allows photography by candle light.

**Dynax 50mm,f/1.7** - This standard lens is still relatively fast - only three lenses in the whole Minolta range offer a wider maximum aperture. It has the same dimensions as the faster lens, but is a full 50g lighter although its closest focusing distance is the same at 45cm. One advantage of the half-stop reduction in speed is, of course, its price. High speed, low weight and low price are the main arguments in favour of standard lenses. But do remember that the 50mm focal length is covered by several zoom lenses in the Minolta lens range.

AF 50mm,f/1.4

AF 50mm,f/1.7

## Medium telephoto focal lengths

**AF 85mm,f/1.4** - The super fast 85mm telephoto lens in the Minolta AF lens range, weighing 550g, is particularly favoured by professional photographers. Its high speed is suitable both for atmospheric shots in low light, and for making full use of differential focus. The advantages of a wide maximum aperture become particularly apparent with portrait shots, where a busy background dissolves into unsharpness. Another advantage is the ability to work with fast shutter speeds even in poor lighting conditions. A so-called 'floating effect', where elements move in different directions relative to each other during focusing, is used in the construction of this lens to improve its reproduction quality.

**AF 100mm,f/2** - Although it has a focal length 15mm longer and a maximum aperture of as much as f/2, the 100mm telephoto lens is 70g lighter than the super-fast 85mm lens. At 55mm, its filter size is exactly 17mm smaller. Which of these two similar lenses you

AF 100mm,f/2                    AF 135mm,f/2.8

prefer all boils down to photographic preference. Both are excellent for portrait and landscape photography. Just decide whether you prefer the slightly longer focal length, the higher speed, or the lower weight. Price, too, will be an important factor in your decision. Both the 85mm and the 100mm are top class performers.

**AF 135mm,f/2.8** - The slightly slower AF 135mm,f/2.8 is an inexpensive alternative to the shorter 85mm and 100mm lenses. It is just over one-third of their price, but it only weighs 365g (185g less than the 85mm lens) and is less than one centimetre longer. This lens, too, is excellent for portrait photography, and it can be used for sports and action shots over medium distances. As its closest focusing distance of 1m is the same as that of the 100mm lens, it even provides a larger reproduction ratio in the close-up range. This means that subjects smaller than an A5 sheet of paper will fill the frame.

## Apochromatic lenses

Chromatic aberration is an optical fault that has caused optical designers many problems over the years. Although spherical aberration has been largely eliminated in modern lens designs by using special aspheric elements, chromatic aberration is corrected by glass with special refractive properties.

Chromatic aberration is a colour fault which occurs because different colours of the spectrum are refracted in different ways when they pass through a lens. This results in different coloured images varying in their size and in their position along the optical axis. These are called magnification and focus differences. Such faults are manifested in colour fringes and unsharpness in the final photograph and the effect becomes particularly noticeable with longer telephoto focal lengths. On most lenses this fault is only corrected for two colours, and this generally produces an acceptable impression of sharpness.

The correction is achieved by combining several elements which cancel out each other's faults. Lenses which are corrected for two colours - usually yellow and purple - are called achromatic lenses. The combination of positive convex and negative concave elements made from different types of glass is usually sufficient to achieve the correction. The correction of chromatic aberration for the whole spectrum of blue, green and red is far more difficult. Lenses corrected in this way are called apochromatic lenses, and Minolta offers this type of correction in the AF 80-200mm,f/2.8 Apo and all fixed focal lengths above 200mm.

**AF 200mm,f/2.8 Apo** - The fast AF 200mm,f/2.8 Apo was designed for the special requirements of photojournalists and animal and sports photographers. Internal focusing is particularly fast and accurate, and can be speeded up even more by preselecting the focusing range. This is done by setting the furthest or closest focusing distance using a special ring, so that the autofocus does not have to travel across the entire focusing range. As you may know, focusing movement is normally greater in the close-up range than at greater distance. By limiting the close-up range to 5m for sports shots, for example, the focusing speed is at least doubled.

Apochromatic correction is achieved by using two elements made of AD glasses (glass with 'anomalous dispersion'). As such

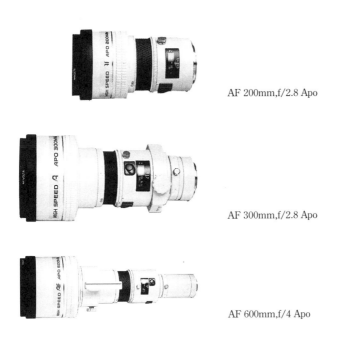

AF 200mm,f/2.8 Apo

AF 300mm,f/2.8 Apo

AF 600mm,f/4 Apo

elements are more heat-sensitive than others, the lens barrel is beige which reflects heat rays better than the usual black.

**AF 300mm,f/2.8 Apo** - The 300mm telephoto lens is the most commonly used lens among sports photographers. A high speed allowing fast shutter speeds is a basic requirement for sporting events often take place in poorly lit halls and freezing fast movement is essential. Like the 200mm lens, Minolta's AF 300mm,f/2.8 Apo includes two AD glass elements which give particularly good colour correction and the focusing range can also be limited using a ring. Thanks to internal focusing, where only one group inside the lens is moved, the length of the 300mm remains constant. Its weight of almost three kilogrammes and the long focal length

generally necessitate the use of a tripod or a monopod. This heavy lens has a special tripod ring, as it could damage the camera bayonet if it were supported by the camera alone. This ring is placed so that the centre of gravity is positioned perfectly even when fitted to a tripod. The lens can be turned in the tripod ring to allow you to change between landscape and portrait cropping.

**AF 600mm,f/4 Apo** - The AF 600mm,f/4 Apo super telephoto lens is twice as heavy as the 300mm. The longest telephoto lens in the Minolta range, it is also one of the fastest of its kind. Its main uses are for professional sports and animal photography, but because it is almost prohibitively expensive (in roughly the same price bracket as a small car), this optical delicacy will remain a rarity even among professionals. AD glasses were used in the construction of the 600mm lens, too. But in addition, it has an achromatic coating which improves its colour reproduction and contrast. Like other Apo telephoto lenses, it has internal focusing, focusing range preselection and a tripod ring. It's not only the photographer's wallet that is stretched to its limits by this lens, it also weighs as much as 11 pounds. As handheld shots without camera shake are impossible with this super telephoto lens, a particularly sturdy tripod needs to be added to the weight of the lens.

The large, expensive front element is protected by a colourless filter supplied with the lens. Six glass filters which slot into the lens barrel are also supplied. They are part of the optical construction of the lens, which means that one always has to be placed in the filter compartment. The set includes one colourless filter (Normal), one yellow (Y-52), orange (O-56), red (R-60), neutral density (ND-4X), and skylight (1B). Two conversion filters (A/R 12 and B 12) are available separately.

The lens has a sturdy handgrip for easy transport and the storage case comes supplied as standard.

## AF Apo tele converters

Tele converters are a useful invention, allowing the focal length of a lens to be increased by a certain factor. Such converters, placed between camera and lens to increase the focal length, used to reduce the speed of the lens and its optical quality. The loss of speed with an increase in focal length is an inescapable optical law but the AF Apo converters for Minolta Apo lenses are designed to be part of the lens construction. Like the lenses themselves, they have an integral ROM-IC, which feeds the camera all data necessary for focusing and exposure control, including the actual aperture and focal length value. This means that the actual aperture value is displayed on the data panel of the camera, making manual correction unnecessary. Their computer-designed optical construction made from special glasses with an achromatic coating guarantees sharpness with plenty of contrast and excellent colour reproduction, even at the maximum aperture. The autofocus function, too, is hardly affected by the use of Apo tele converters. A transmission mechanism in the converter connects the AF coupling devices of camera and lens. Minolta's range includes two such converters, with factors of 1.4X and 2X.

**AF 1.4X Tele Converter II Apo** - The AF 1.4X Tele Converter Apo is specifically designed for Minolta AF Apo lenses with focal lengths above 200mm, increasing their focal length by a factor of 1.4. This means that the 200mm lens becomes a 280mm lens, the 300mm a 420mm and the 600mm a 840mm, reducing the speed by one aperture stop each time. But as all Apo lenses are very fast to start with, this does not make much difference. The converters have the same beige-coloured design as the Apo lenses, and they form a harmonious-looking unit together.

**AF 2X Tele Converter II Apo** - The AF 2X Tele Converter Apo doubles the focal length, and is also designed specifically for Minolta's Apo telephoto lenses with focal length above 200mm. It turns the 200mm lens into a 400mm lens, the 300mm into a 600mm, and the 600mm into a super telephoto lens with 1200mm focal length. At two aperture stops, the loss in speed becomes more noticeable here. But thanks to the high speeds of Minolta's Apo

telephoto lenses, the speeds are still quite acceptable, comparing favourably with the original focal lengths of other manufacturers. The 2X converter also has its own ROM-IC, which transmits all data relating to the increase in focal length to the camera computer so that the data panel of the camera shows the actual values and conversion is unnecessary.

The high optical quality of the converter allows unrestricted use with maximum aperture, a fact which makes the loss in speed even more acceptable.

Teleconverter Af-Apo 2x (right)
Teleconverter AF-Apo 1.4x (left)

## Reflex lens

**AF Reflex 500mm,f/8** - The size and weight of very long telephoto focal lengths makes them more difficult to use, particularly for travel photography. This is why Minolta's lens range includes one real speciality in the shape and form the Minolta AF Reflex 500mm,f/8, the first reflex lens for an AF camera.

Reflex lenses are relatively small and light, and the Minolta AF Reflex 500mm weighs just 665g. Used on the i and xi series cameras (except the 3000i), it focuses automatically, on the Minolta AF cameras it has to be focused manually. It consists of 7 elements in 5 groups, including two concave mirrors which divert the path of

AF-Reflex 500mm,f/8

the light through the lens. The special construction of this lens means that it cannot have an iris diaphragm, and that a filter is part of the optical construction. This also means that a filter needs to be in the compartment in front of the lens bayonet at all times.

As this lens does not have an iris diaphragm, it is always used at full aperture. The depth of field is fixed and cannot be increased in any way but the ND4-X neutral density filter supplied reduces the speed, and imitates a smaller aperture without affecting the depth of field. The exposure is always determined by the shutter speed - even if the camera is in P mode.

Shots taken with reflex lenses are particularly easy to recognize if highlights or light reflections are included in the unsharp areas of the shot. They don't appear as bright spots, but as bright rings or 'doughnuts', an effect can create an interesting look. This lens does take some getting used to, but once you have discovered its appeal, you won't want to do without this Minolta speciality.

## AF macro lenses

Minolta offers two macro lenses with different focal lengths for its autofocus SLR cameras. The shorter 50mm focal length is suitable for repro applications, where you are working at relatively short distances from a repro stand. A longer focal length, such as the 100mm lens, is to be recommended for close-up nature photography, where you need to keep some distance from the subject. Both lenses allow reproduction at life size, with a reproduction ratio of 1:1. Which lens you go for depends on the potential application, as well as on weight and price considerations. If you only take photographs of flowers - which don't run or fly away like beetles or insects - you will be well served by the lower-priced 50mm. If you have to keep your distance you need the telephoto macro. Otherwise they both offer the same reproduction ratio, as well as a speed of f/2.8.

**AF 50mm,f/2.8 Macro** - The AF 50mm,f/2.8 Macro can be focused continuously down to the reproduction ratio of 1:1 from a distance of 20cm. Thanks to a special 'double floating system', reproduction faults such as curvature of field and spherical aberration are largely eliminated. As three groups move in relation to each other during focusing, the lens offers fast focusing as well as high speed. The closest focusing distance is defined as the distance between the subject and the film plane. As the lens barrel is extended to its maximum position to achieve the largest reproduction ratio, the distance between front element and subject is substantially reduced, which can restrict the number of ways you can light the subject. As the reproduction ratio increases, the depth of field becomes more and more shallow.

---

*When shooting with wide-angle lenses, it is important to take into account the foreground when composing.*

The exact reproduction ratio is shown in the position of the focus ring. The engraving 1:1 indicates actual size, 1.2 means five-sixths of actual size, and 1.5 two-thirds. Things get easier after the 2, which indicates a reproduction ratio of 1:2; three then stands for 1:3, and so on, down to 1:9, where the subject is reproduced on the film at one-ninth of its actual size.

For optimum flash lighting, the Macro Flash 1200AF can be attached to the 55mm filter thread of the AF 50mm,f/2.8 Macro.

**AF 100mm,f/2.8 Macro** - With the longer 100mm focal length and the 1:1 reproduction ratio, the distance between film plane and subject is approximately 15cm greater. This has many advantages and there are less problems with lighting, and the shooting distance is greater, which is vital for close-up shots of small animals. However, the longer focal length is also substantially more expensive, almost twice the price of the 50mm macro lens.

Like the 50mm macro, the sophisticated optical construction of the 100mm macro includes a 'double floating system', necessitating 8 freely moving elements. Three lens groups move simultaneously during focusing, which means that the lens barrel could be kept relatively short. The AF 100mm,f/2.8 Macro has the same focusing range limiter as the Apo telephoto lenses, in order to avoid the need for the autofocus to travel the entire distance range when working at limited shooting distances. This has the benefit of substantially increasing the focusing speed. For short shooting distances the focus range can be limited to 54cm, and for shots across greater distances the range can be limited from 59cm to infinity. Macro lenses generally offer excellent reproduction qualities in the distance range and so the Minolta AF 100mm Macro makes an excellent portrait lens.

*The graphic foreground and background form an attractive contrast with the main subject of this shot.*

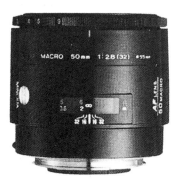
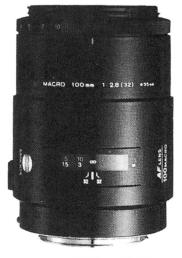

AF 50mm,f/2.8 Macro                                  AF 100mm,f/2.8 Macro

## AF Macro Zoom 3X-1X,f/1.7-2.8

This particularly fast lens is designed for special applications in the extreme close-up range. It works with a limited range of reproduction ratios from 1:1 to 3:1, allowing reproduction from actual size to three times actual size.

Photography with large reproduction ratios is normally very difficult and cumbersome. A number of the settings needed are handled automatically by this AF Macro Zoom. For example, the power zoom carries out the axial movements of the front mounting, which carries the optical system, and that of the rear mounting that carries the camera body. The middle mounting, which should

114

normally be attached to a tripod, remains in a fixed position relative to the subject plane. The reproduction ratio can be selected continuously between 1:1 and 3:1, and is shown on the reproduction ratio scale of the lens.

Once the reproduction ratio has been selected, automatic focusing works as with other AF lenses. The autofocus has a type of internal focusing which keeps the relative positions of subject, lens and camera body constant. If desired, the lens can also be focused manually with a knob which causes lens and camera to move together along a focusing track.

The optical construction includes floating elements to reduce spherical and chromatic aberration. The working distance of the lens is between 25.1mm (at 3:1) and 40.1mm (at 1:1).

The lens can be used either in program mode or with manual control of shutter speed and aperture. In program mode the camera automatically compensates for the loss of light which occurs at large reproduction ratios. This means that you do not have to calculate magnification factors.

Another unique feature of this Minolta AF Macro Zoom is the motorized image framing. As it is often quite difficult to determine the framing precisely for magnification shots, this lens can automatically adjust the camera position. By using a slide switch on the lens base (the same switch as is used for zooming) the camera body can easily be turned to the desired framing over a 135° range. The function of the zoom switch is changed by a selector switch. The filter size is 46mm.

The power required for the zoom motor and for moving the camera is supplied by a 6-volt lithium battery, which is inserted into a battery chamber on the lens mount facing the camera body.

But all these features, plus the extremely high speed of this lens (f/1.7 at a reproduction ratio of 3:1, f/2.8 at 1:1), do have their price, and this lens is really only used for specific professional applications, very rarely by amateur photographers. This 1100g lens is supplied with an dedicated macro tripod which allows the camera/lens unit to be positioned above the subject, like a microscope.

The special Minolta Macro Flash 1200AF can be attached to the front of the lens for macro flash photography. But you should remember that the autofocus will not work on predominantly red, yellow or white subjects if it is used in conjunction with the focusing lamps.

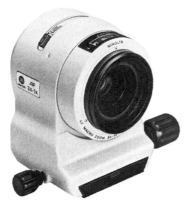

## Minolta AF Macro Zoom 3X-1X, f/1.7-2.8

The first autofocus lens in the world for reproduction ratios between 1:1 and 3:1 (actual size to 3x magnification).

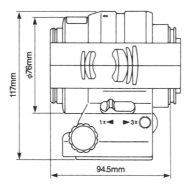

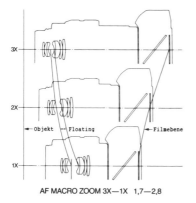

AF MACRO ZOOM 3X—1X   1,7—2,8

In the zoom setting, the front and rear mounts carrying the camera body and optical system move in opposite directions along the axis. The central mount, to which a tripod can be connected, stays in a constant position in relation to the subject plane. A floating element system is used to reduce spherical and chromatic aberration. In this system the distance between the two components changes in relation to the reproduction ratio.

116

Although the speed of the lens changes with the reproduction ratio, it is not difficult to determine the exact exposure with a manual exposure meter. Unlike conventional bellows, the aperture shown in the camera viewfinder or data panel is always the actual aperture with this macro zoom.

This expensive lens is supplied with a rear and front element cover, as well as a hard case and macro tripod.

The appeal of this winter landscape lies in its graphic composition and in the clever choice of perspective. Photo: R. Hagenauer

# Tips for better shots

Whilst the first part of this book is largely devoted to the technology of the 3xi and SPxi, the following pages are given over to photographic practice. Even if the majority of settings on both cameras could be largely automated, the final results would be strongly dependent on whether photographers use the many automatic functions sensibly and for the right subject.

As not every photographer has the same interest in all subject areas, the preferences of each person will determine how their photographic equipment is put together. The animal photographer, for example, will need different lenses and accessories than someone who is more interested in landscape photography. Travel photographers will appreciate light equipment that can be used in as many situations as possible, and if you want to take frame-filling shots of small subjects you will, once again, choose altogether different tools. The technology of the 3xi and SPxi is designed for general snapshot and action photography. Their great strengths become apparent in conjunction with the new Power Zoom and xi lenses and the auto stand-by zoom function.

But the optimum selection of photographic hardware is not the only factor that determines the end result; it is also important to select the right exposure program and adapt it to the given shooting situation. The question of whether you should use flash, or make use of the ambient light to create an atmospheric shot, is just as important as your choice of film material. Tips on assembling appropriate equipment for certain photographic situations are only intended as a guide. Many areas overlap, and many photographers are interested in more than one subject area. This is why the suggestions are put together so that they're as universally applicable as possible, while still relevant to the specialist applications.

# Tips for better snapshots

Fast snapshots with the P program are the real strength of the 3xi and SPxi. Thanks to the auto stand-by zoom function and the automatic activation of autofocus and exposure metering system as soon as the camera is put to the eye, the photographer can frame his subject and fire without having to do a lot of thinking and without needing to make fussy settings. The integral flash unit of the 3xi ensures sufficient light and provides AF illumination even in darkness. You won't miss any subject simply because the camera wasn't ready to shoot at the decisive moment. Thanks to this technology, snapshot photography has come even closer to its age-old attraction: the documentation of the small things in life that would pass us by unnoticed were it not for photography and the attentive eye of the photographer. The meaning of such fleeting moments only becomes clear when they are captured forever in a photograph. Snapshots can be lovingly observant, ruthlessly revealing or humorous caricatures. A good photographer can tell a whole story with a single snapshot.

The essential thing is to catch the moment which will document an event in such a way that a single picture is enough to present the viewer with the entire gist of a situation.

Good snapshots are therefore rarely achieved accidentally. An experienced snapshot photographer anticipates how a situation will develop and is ready to press the shutter button at the right moment. Nothing will get in the way of taking the shot at the decisive moment. The fast autofocus of the 3xi and SPxi is a welcome help on such occasions but it is only the auto stand-by zoom function that turns them into real snapshot cameras.

Even the integral flash unit of the 3xi, or a unit mounted on the SPxi, is activated and fired automatically. Snapshot opportunities don't leave us much time for fiddling with the camera. We have to be able to respond spontaneously and quickly. We have to anticipate how a situation will develop and when events will reach their climax. Good snapshot photographers are experienced observers and excellent judges of character, they know the best vantage points and where the most interesting things will happen. They never go where everybody else is going.

Apart from an instinctive feel for a photographically promising situation and fast reactions, snapshot photographers also need

patience. Like a hunter, they must be able to wait until the time is right to take a shot; and that shot has to be on target. You don't often get a second chance. Snapshot photographers must have the gift of seeing what is special in everyday situations and not be content with voyeuristic observing. They look behind the surface of things by capturing on film the decisive moment that most people may not even have noticed.

The scope for snapshots is huge. They can be affectionate or revealing portraits. They can show the behaviour of individuals or of groups of people. Snapshots can be found in sport as well as animal photography. They're not called the high art of photography for nothing. The snapshot is the one picture of an event that reveals its whole story.

---

### How to take original snapshots

* The main switch of the 3xi and SPxi is set to **ON**
* Select P mode
* In low light, attach a flash unit (SPxi) and switch on

### Equipment

**Lenses**
Minolta AF Zoom xi 28-80mm,f/4.5-5.6 and
Minolta AF Zoom xi 80-200mm,f/4.5-5.6 or
Minolta AF Zoom xi 35-200mm,f/4.5-5.6

**Accessories**
Minolta 2000xi program flash unit or for 3xi
Minolta 3500xi program flash unit

The tips on snapshot photography also apply to the following areas:
* Action * Pets * Children * Markets * Travel * Party * Portrait
* Sport * Wildlife * Fun fairs * Zoo *

---

Thanks to its integral flash unit, the 3xi is always ready to shoot, even in low light.

## Tips for better photographs of children

For a variety of reasons children are one of the most popular photographic subjects. Photography is an excellent medium for documenting how children change as they grow up. As these changes happen particularly quickly when children are small, you should grasp every opportunity to take a photograph as their value is only realized many years later. However, children can quickly get tired of being pursued by parents, relatives, friends and acquaintances brandishing a camera. It's better in the long run to go without the odd shot, rather than provoke a dislike of photography by being too obtrusive. In general, children like being photographed and taking photographs themselves. Their childlike joy in posing and their natural behaviour in front of the cameras are reasons why children like being photographed and, in turn, why there are so many successful photographs of children. Children don't clam up in front of the camera because they're worried about looking silly.

The auto stand-by zoom function means that the Minolta Maxxum/Dynax photographer will no longer miss any snapshots. Photo: R. Hagenauer

They become inhibited for completely different reasons, for example, if the photographer asks them to do something that either doesn't seem natural to them, or they simply don't want to do at that precise moment. But it can also happen when they're deliberately trying to pose and then become inhibited.

This is why being photographed should be something natural for children. It shouldn't prevent them from doing other things that might appear more important to them at the time. They should feel neither disturbed nor annoyed by the photographer. The dreaded words 'Give us a smile' can nip every smile in the bud. The more natural it is for the camera to be around, the more it is part of everyday life, and the fewer 'special tricks' are demanded for a photograph at the wrong moment, the more natural your children - or the children of friends and acquaintances - will behave in front of your camera. If you don't spend any time with them on other occasions, you're unlikely to get a good shot. However tempting it may be to take a surprise snapshot of a child feeling unobserved, it's better to give it a miss. For politeness' sake, children, like adults, shouldn't just be 'shot', they should know they're being photographed.

If you want to take good shots of children you don't know well, you have to be prepared to sacrifice a great deal of time. You have

to win their trust, and this can only be achieved if you come down to their level. And this is one of the most common mistakes of child photography. Adults usually photograph children from above. Except in some instances, this produces an ugly perspective with large heads and short legs, particularly with short focal lengths. If you come down to the child's own level and squat down a little, you'll notice that your shots get better. There are two reasons for this: first, the perspective is more favourable and second, the communication, the contact, with the child is better.

Some of the points made on snapshot photography equally apply to photographing children. The photographer needs a lot of patience until he manages to catch the right moment, the desired facial expression, the expected gesture. Here, too, you often need to wait for a long time and then react particularly quickly at the right moment.

The most important thing is that the children shouldn't lose their enjoyment of photography, and that they don't feel disturbed by the camera. Children should only be 'directed' with the utmost caution. After all, they don't understand why they're supposed to repeat what they just managed to do so brilliantly. The request 'Do that again, please' may be successful when the whole thing is fun but, equally, it can easily provoke irritation.

At home, where you're photographing your own children, the camera should therefore be ready to be grabbed wherever the family spends most time. Often this is the kitchen rather than the sitting room. It's unlikely that you'll be able take a tidily stored camera out of the cupboard or photo bag for a spontaneous snapshot. Keep a spare film and a fresh battery handy and if you've only got two or three frames left at the end of the day, it's advisable to take those few shots. Just shoot what you've always wanted to photograph but which was never important enough to make you load a fresh film like the chaos left behind by your children, or the things your child is particularly fond of, such as a favourite doll or teddy bear. Then load a new film - the most interesting subjects usually crop up when the film is full or the camera empty.

Child photographers must be able to respond quickly to spontaneous or sudden events. Extensive preparations with the camera are rarely possible, nor are necessary with the 3xi and SPxi. The auto stand-by zoom function in particular can be a great help in child photography. It's always quicker to adjust the suggested focal

length to the one you want, but usually the camera's suggestion can be accepted without correction.

---

### How to take impressive photographs of children

* The main switch of the camera is set to **ON**
* Auto stand-by zoom is activated
* In low light attach a flash unit and switch on (SPxi)

### Equipment

**Lenses**
Minolta AF Zoom xi 28-80mm,f/4.5-5.6 and
Minolta AF Zoom xi 80-200mm,f/4.5-5.6 or
Minolta AF Zoom xi 35-200mm,f/4.5-5.6

**Accessories**
Minolta 2000xi program flash unit, or for 3xi
Minolta 3500xi program flash unit

---

## Tips for better portrait shots

Portraits are one of the classical photographic subjects. But really successful portrait shots are far more than natural pictures of faces. Ideally, portraits reveal the character, the typical behaviour, of a person. A really good portrait presupposes that the photographer knows the subject, or at least has spent some time with them.

Portraits don't just give clues about the subject, but also contain information on their relationship with the photographer. Portraits can romanticize, flatter, beautify. But they can also expose, reveal, caricature or distort. Portraits that aren't just flattering, but allow a glimpse beyond the surface, are particularly in demand in photojournalism and news reporting. Conversely, you will usually try to show friends from their best side. And to do this, there are a few simple tricks.

The auto stand-by zoom function is a great help, particularly for spontaneous snapshots of children.

All too often photographers concentrate so hard on their subject that they forget to give any thought to creating a backdrop. Backgrounds for portrait shots should be as unfussy as possible, and their colours should be balanced to the subject's hair and clothing. A dark background is usually a more favourable contrast

to someone with blond hair, and conversely a light background suits someone with dark hair. But here, too, the exception proves the rule.

Short telephoto lenses are considered ideal focal lengths for successful portrait shots. Focal lengths between 80mm and 200mm produce a natural-looking perspective and allow the photographer to keep a certain distance from the subject, so that they don't feel too threatened by the camera. But at the same time the distance isn't great enough to make communication between subject and photographer difficult.

Another argument in favour of telephoto lenses for portrait shots is their shallow depth of field. If the iris diaphragm is opened fully, the depth of field shrinks to a minimum, allowing the subject to be rendered sharp while the unsharp background appears as if a coloured screen. To dissolve the background completely, the subject should be sufficiently far away from it and even for flash shots, a certain distance from the background is advisable to prevent ugly harsh shadows.

Unfortunately most portraits are more or less successful souvenir shots. They are only of interest to people who know the subject and were present when the shot was taken. It is often very disappointing when a third party is left unmoved by a photograph that shows the person the photographer loves most. If portraits are to be more than private souvenirs, the photographer has to try a little harder.

The first rule is: limit yourself to what is essential. The tighter the framing, and the fewer details that don't say anything about the subject, the more expressive the shots will be. So if you want to show a face, it should fill the frame as much as possible. With women or girls with long hair in particular, the framing can be so tight that the hair almost frames the face. Whereas portraits of men can cope with direct harsh lighting, soft indirect light is required for women. In this case it is advisable to use the remote control function for the Minolta 3500xi program flash unit and fill in with the integral flash unit. The integral flash can then prevent unflattering shadows under the eyes, when the main flash is bounced from the ceiling. But the remotely controlled flash can also produce backlight effects at a ratio of 1:2, or be used to set highlights on the hair.

The character of light is very important for portrait shots. Side or backlight is appreciated by many portrait photographers because

it makes faces look more three-dimensional although directional light also creates harsh shadows. But it would be a shame to remove these completely with the integral flash unit. Instead, many photographers place white cloth, cardboard or styrofoam boards near the sitter to help soften shadows. A reflector on the flash unit can also soften shadows.

Portrayer attachments in different strengths are available from Minolta to create particularly soft portraits. These lens attachments produce a gentle soft-focus effect, and can be used effectively not only in portrait photography, but also for landscape and still life shots. Whereas the photographer can influence the external conditions when taking portraits of friends, children or acquaintances, the documentary portrait demands flexibility, spontaneity and precision. We have all seen impressive shots by travel photographers - the Moroccan water carrier, the Greek fisherman or the Tibetan monk. But the vegetable seller in a local market, the coach-driver on Brighton sea-front, or the waitress at the restaurant can also included in this subject area. These portraits demand a completely different technique from the photographer. Photo opportunities arise from every situation, but however tempting it may be to take a shot of somebody with a long focal length from a great distance, it is also impolite. There are good reasons why we have legal rights over photographs of ourselves.

But even basic politeness should prevent every photographer from simply 'shooting' somebody. Even where your linguistic abilities may be insufficient to ask permission when you're abroad, eye contact, pointing at the camera together with a nod and a smile are often enough to secure your subject's agreement.

But then you need to be quick - nobody spends much time posing for a stranger. You'll have no choice but to improvise, making the most of the current light conditions and surroundings. In most cases you won't have enough time to look for a suitable shooting position either. A zoom lens, such as the Minolta AF Zoom xi 28-80mm,f/4.5-5.6, is ideal for such opportunities, allowing you to compose the shot at lightning speed. The Minolta AF Zoom xi 35-200mm,f/4.5-5.6, too, is very suitable for such situations. The integral flash unit of the 3xi or the small 2000xi clip-on flash unit can be used to fill in, in order to prevent ugly shadows or excessive contrast.

The camera's automatic continuous focus function is a useful feature for shots of subjects moving towards the photographer and the image will always stay sharp. The photographer can concentrate fully on the facial expressions and the right moment to release the shutter. You need to set the camera to aperture priority mode and open the lens aperture fully to make intrusive details dissolve into unsharpness. The Minolta AF 85mm,f/1.4, Minolta AF 100mm,f/2 and Minolta AF 135mm,f/2.8 are also ideal lenses for portrait shots.

---

## How to take attractive portrait shots

* Set the camera to aperture priority mode
* Preselect a wide aperture for shallow depth of field
* Medium to long focal length
* Fill in with integral flash unit in backlight and with excessive contrast

## Equipment

**Lenses**
Minolta AF Zoom xi 28-80mm,f/3.5-4.5 or
Minolta AF Zoom xi 35-200mm,f/4.5-5.6
Minolta AF 85mm,f/1.4
Minolta AF 100mm,f/2
Minolta AF 135mm,f/2.8

**Accessories**
Minolta 2000xi program flash unit or
Minolta 3500xi program flash unit

---

The fill-in flash function of the Minolta 3xi is recommended for portraits of dark-skinned people.

## Tips for better sport and action shots

Sport, along with travel and photography, is one of the most popular hobbies. So what could be more obvious than to keep alive your memories of sport in photographs. I'm not going to talk about

professional sports photography, but about the souvenir photographs we, as active amateur sportsmen, like to take of our teammates and partners.

Sport means movement, and movement in turn creates unsharpness in photography if we are unable to freeze it with particularly fast shutter speeds. The 3xi and SPxi offer the photographer a top shutter speed of 1/2000sec. Around 1/500sec to 1/1000sec will usually be sufficient for most types of sport such as surfing, skiing and all ball games. As long as the light conditions allow it, the camera will always suggest a shutter speed that is fast enough to avoid camera shake, but this doesn't necessarily mean it will freeze all movement. It is therefore a good idea to set the aperture ring to the smallest f/number - that is, the maximum aperture - and to work in aperture priority mode when taking sports and action shots. Alternatively, if there is enough light, a sufficiently fast shutter speed can be preselected in shutter priority mode while the camera automatically takes care of the aperture. But you should in any case occasionally check the shutter speed on the data panel.

As for most subjects, the rule in sports photography is, the less distraction from the main subject, the better. This means taking frame-filling photographs wherever possible. This causes the sports photographer a dual difficulty. First, you need to keep a certain distance from events in order not to disturb or even impede the sportsmen, and second, the subject constantly changes its distance from the photographer. So telezoom lenses with a wide focal length range would be the ideal equipment for sports photography, if only it weren't for an added problem - the fight with light and the fast shutter speeds required at the same time. If you're shooting outside in sunlight there's rarely any problems. Even with long focal lengths, fast films around ISO 400/27° can produce shutter speeds that prevent camera shake and speed blur. But things are different with sports events inside as only fast lenses used with fast films will help you here. The Minolta AF 200mm,f/2.8 Apo and the 300mm, f/2.8 Apo are the ideal equipment for such occasions but, unfortunately, these top class lenses are also particularly expensive.

Photographs of sporting events take a fraction of a second out of a whole movement or sequence. So the phase of movement captured on film must represent what is typical, the climax, the key fascination of the particular sporting discipline. A good sports

photographer therefore needs to be familiar with the sport, be aware what it is all about and what is important. So he won't photograph the pole-vaulter when he puts down the pole, but at the point when he lets go of it, seemingly floating on air. And you won't shoot the skier on a flat section of the piste, but when jumping over the edge. Equally, you'll try to catch the goalkeeper, not during a goal kick, but making a brilliant save. Good sports photographers need to know the sequence of events, anticipate it and know which situations can produce spectacular photos.

Movement sequences have a certain rhythm. They have a beginning, a climax and an end. Usually, these are also the three phases worth photographing. But the most impressive shots will always be those that show the moment which decides on success or failure. So the moment when a movement reaches its climax (for example, when the pole-vaulter seems to be floating above the pole) is the one when you need to press the shutter release button. The moment for a successful shot isn't when the gymnast prepares for the piece de resistance on the horizontal bar, but when he's posed above the bar doing a handstand.

Even the fastest autofocus is too slow for fast sporting disciplines such as ice hockey or motor racing. An old professional trick, preselecting the focus, will help here. Select a point - perhaps a bend on the race track - focus, and wait until the car reaches the area of sharpness. With the 3xi and SPxi you can use the focus lock function, or push the AF switch downwards to manual focus after you have made the preselection. Alternatively, simply pull the zoom ring of a Power Zoom or xi lens towards the camera. If you don't use the AF switch, the camera returns to AF mode as soon as you let go

*Thanks to their large reproduction ratios, the Minolta AF zooms are well-suited for frame-filling shots of smaller subjects.*

of the zoom ring. Having switched to manual focus, you can release the shutter at any time. In this mode, too, the green LED in the viewfinder will confirm that the focus has been found.

Of course, it isn't just the highlights of a sporting event that will yield impressive shots. Observations at the fringe of events, the sportsman's joy at his success, triumphantly throwing his arms into the air after victory, or the moment of disappointment, defeat or exhaustion. All these can produce great shots.

They all become more meaningful as part of a whole sequence of shots. Series that show the entire development, the complete process of an event, present a challenge for every sports photographer. Use your camera to document the training, the preparations for an event, everything that goes on at the fringes - often this can show the mood and atmosphere better than the event itself. Shots of the presentation ceremony and the subsequent celebration in the club house will complete your documentary.

It doesn't always have to be the big events where good sports shots are created. Sports day at school, the local club competition, the riding contest in your village - all those are opportunities that can fill whole albums. Don't be mean with your materials, but don't get sidetracked either. Have a feel for the essential, despite all the attention to detail.

Many sporting disciplines take place in badly lit halls. Remember that the integral flash unit only has a limited range, and that even more powerful flash units will only be sufficient when used with extremely fast film and in exceptional cases. Hall or stadium lighting often has the characteristics of artificial light which doesn't matter much with negative film. But when shooting with daylight-

---

*Flowers are an ever-popular subject for photographers as well as painters. Fill-in flash can often add colour to a backlit shot.*

135

balanced slide film, the colour temperature can produce an unwelcome green or reddish-brown cast.

Filtering with so-called conversion filters is usually out of the question, as these filters swallow so much light and can leading to sluggish shutter speeds. Using artificial light slide film, on the other hand, isn't the ideal solution either, as this is usually only available at slow speeds. One exception is the Scotch 640 T at ISO 640/29°.

---

### How to take exciting sports shots

* Select shutter priority mode and a fast shutter speed, or select a wide aperture for fast shutter speeds in aperture priority mode

### Equipment

**Lenses**
Minolta AF Zoom xi 28-80mm,f/3.5-4.5 and
Minolta AF Zoom xi 100-300mm,f/4.5-5.6
possibly Minolta 300mm,f/2.8 Apo

**Accessories**
Minolta 3500xi or 5200i program flash unit

---

## Tips for better animal shots

Hunting with the camera is an experience of a special kind. It includes all the essential elements of a real hunt, but its outcome is a lot more positive. The hunter with the camera doesn't kill the prey, he only takes home its photograph as his trophy. Photo tourism, still increasing in popularity, has contributed towards saving many species of animals from extinction. The photographs of the Ameri-

can scientist Dian Fossey, who lived with the mountain gorillas of Ruanda for many years, have touched millions of people worldwide. They have attracted visitors from all over the world and have drawn the public's attention to the plight of these threatened animals. Dian Fossey paid with her life for her love of the gorillas. But she awakened in many tourist the desire to observe these lovable apes in their natural habitat; and this finally made the governments of Ruanda, Uganda and Zaire devote more effort to protect these animals, and in the last few years the population of mountain gorillas has started to increase again for the first time. Without photo tourism in Africa the population of most game reserves would have decreased a long time ago. They would have been plundered by unscrupulous poachers, and bled to death by well-heeled hunters.

A photographic hunt for animals in the wild doesn't just require photographic know-how, but also a knowledge of the behaviour and habits of these animals. Not everybody who likes to watch animals with the camera has this knowledge, and it isn't always absolutely necessary either. In most game reserves the tourist isn't allowed to roam without a guide who knows the area and is familiar with the dangers of the wild and the animals living in it. And you don't have to be an enthusiastic animal photographer to cherish the desire to capture on film your safari experiences in Africa or even the local wild park. Gamekeepers are familiar with the peculiarities of each animal and bring the visitor close enough to the subject so a super telephoto lens isn't really necessary.

In animal photography, patience and fast reactions are important prerequisites for success. Animals don't understand the needs of photographers, and much patience and persistence is needed until you really get their best side facing the camera. And if they do show themselves the way you'd like to get them in the shot, it's usually only for a fleeting moment before they run out of shot and retreat into thick shrubbery.

In the game reserves of Africa the photo hunt will usually take place from the safety of a car. In many places animals are used to vehicles so remain undisturbed. In fact if you're in a car the chances are lions won't give you a second glance, and elephants will rumble on undisturbed, as long as you respectfully keep the necessary distance.

To get good shots in situations like this you don't need any wildly specialized equipment. The 3xi or SPxi with the Minolta AF Zoom xi 100-300mm,f/4.5-5.6 is quite sufficient. Even the Minolta AF Zoom xi 35-200mm,f/4.5-5.6 will still produce presentable shots. As for the exposure, the same tips apply as for sports and action photography. The automatic exposure system of the 3xi and SPxi will always suggest suitable shake-free shutter speeds with the telephoto lens in use. But as animals are most active in the morning or at dusk, using fast films is a prerequisite. Moreover, animals don't keep still, and snapshots of movement - a gazelle in mid-jump, a cheetah on the hunt, or an eagle in flight - are the most fascinating animal shots of all.

To be sure of getting the fastest possible shutter speed it's advisable to shoot in aperture priority mode at maximum aperture.

But you don't have to go all the way to Africa to get good animal shots. At home, too, a photographic hunt can be a magnificent experience. But you should remember that here, too, many species of animals are threatened with extinction. This is no small part thanks to the ruthless methods of some photographers who don't think about the damage they cause by photographing young birds in their nests and breaking off twigs to get a better view. Others track down young deer in their hiding places, even chasing them into more photogenic positions. Today you won't get any recognition or admiration from animal lovers for photographs created in this way. In animal photography great emphasis is now placed on the 'species-friendly' shot.

So enthusiastic wildlife photographers should also be enthusiastic conservationists, and manage without taking a shot if necessary. The good animal photographer selects his shooting position so that he doesn't disturb the animal's habitat. But this presupposes that he knows the habits of the animal he is observing, has found out a great deal of information and consulted experts. If you can manage to go out on a trip with an experienced wildlife photographer you may gradually become a successful animal photographer yourself.

Before a photographic expedition you should also find out about all the legal aspects. In many countries it is now a punishable offence to disturb wild animals - particularly species threatened by extinction - in their hiding, nesting, breeding or living places by tracking them down, photographing or filming them or by similar actions.

138

The intrusive bars of the cage could be almost completely eliminated in this shot by reducing the depth of field. Photo: R. Hagenauer

It can be far less problematic, and certainly just as interesting, to photograph domesticated animals. The maxim of all animal photographers also applies here: the more I know about the animal, the more likely it is that I will get a good shot. If you study the habits of your pets carefully and know precisely how they react, it's more likely that you'll be able to bag better shots than somebody who knows nothing at all. One thing pets have in common with wild animals is never occurs to them to pose for a photographer, but it is easier to anticipate their reactions. So if you want to get a good shot, you need to know what they do on which occasions. In this area of animal photography, many snapshot photography techniques apply. The photographer has to wait patiently for this opportunity and must make use of it very quickly when it arises.

139

Using aperture priority with the lens set to its maximum aperture is the most suitable exposure mode for shots of animals in movement, like a dog catching a ball, or a cat jumping from a window sill. This is most likely to secure a sufficiently fast shutter speed but flash, too, is excellent for freezing fast movements in low ambient light.

One very interesting variant of animal photography is capturing small animals or insects on film. You don't have to travel to distant countries for this and even your front garden will provide plenty of subjects. Beetles, bees, dragonflies, butterflies and everything else that crawls or flies is attractive prey for the hunter armed with only a camera. However, a macro lens is a vital prerequisite for frame-filling shots of small animals. The Minolta AF 100mm,f/2.8, designed to give a maximum reproduction ratio of 1:1, is ideal for this. The shorter Minolta AF Macro with 50mm focal length is less suitable as shooting distances that are too short.

The Minolta Macro Flash 1200AF Set N is a convenient ring flash unit, which mounts on the front element of the macro lens, and has four separate flash tubes that fire simultaneously to give even lighting without shadows. The lamps can also be switched on separately for a more three-dimensional lighting effect and a focusing lamp allows easy monitoring of the viewfinder image and helps the AF system.

Using flash for shooting small animals has several advantages. First, you can use narrow apertures in order to increase the shallow depth of field at high reproduction ratios. Second, flash light allows the use of slow films that offer great sharpness and fine detail. This is essential for recording delicately-limbed insects, the dainty structures of a dragonflies' wings, and also for that fine shot of a finely-spun spider's web.

Long focal lengths and high reproduction ratios are the reason for the shallow depth of field. This is why it is advisable to shoot the subject so that it doesn't extend to much into the depth of the shot. With a 600mm telephoto lens the stag shouldn't be photographed head-on but from the side, nor the dragonfly from the front but from above. This prevents the head from being in focus and the body disappearing into unsharpness.

**How to take fascinating animal shots**

* Select aperture priority mode (A)
* Preselect wide apertures for fast shutter speeds
* Long focal lengths
* Fast films from ISO 400/27°
* Use a tripod or monopod with long focal lengths

**Equipment**

**Lenses**
Minolta AF Zoom xi 100-300mm, f/4.5-5.6 or
Minolta AF Zoom xi 35-200mm,f/4.5-5.6
Minolta AF 200mm,f/2.8 Apo or
Minolta AF 300mm,f/2.8 Apo or
Minolta AF 600mm,f/4 Apo and
Minolta AF 100mm,f/2.8 Macro

**Accessories**
Minolta Macro Flash 1200AF Set N
Minolta 3500xi program flash unit
Tripod or monopod

# Tips for better travel photography

Nowhere do we take more photographs than when travelling. This is understandable because who doesn't want to capture the most vivid memories from foreign countries, to keep them alive for as long as possible and let friends, acquaintances and relatives share the experience.

If you take photographs you get more out of life. This isn't a clumsy advertising slogan for one of the best hobbies of all - it is the

This imposing building only unfolds its full effect in a comparison of relative sizes.

complete truth. No medium is better than photographs at bringing to life memories of events in the distant past. The photographs you bring back from holiday are the most convincing way of sharing your experiences with someone else, and of showing them where you have been and what interested you there.

But travel photography demands a great deal of discipline from the photographer. If you simply start snapping away when you're on holiday, full of enthusiasm for the strangeness of the country you're visiting, your friends and acquaintances will greet the dreaded slide show with nothing but yawns. Piles of photo albums with shots from the most exotic countries won't necessarily enthuse your friends. Unless photographers are able to create images that convey to the viewer what got them so excited in the first place, they will be nothing other than personal souvenirs. The viewer, who wasn't there when the shot was taken, won't feel the roar of the sea, nor hear the chirping of the birds, unless something in the photograph conveys those feelings to him. The photograph can't get across sounds or smells, let alone the photographer's happiness at the moment the picture was taken.

All of this atmosphere has to be achieved by the composition, by leaving out or adding certain creative elements. The tree in the foreground, bent by the wind, has to make you feel the storm; the flowers their fragrance and the dusk the mild air of the summer evening. Of course, if you take photographs simply to aid your own memory, you don't need to worry about such considerations. But if you want to share your experiences with friends and acquaintances, without running the risk of boring them with meaningless little pictures, then you do have to give some thought to the photographic interpretation of what you are seeing.

It is said that William Fox Talbot, the inventor of the photographic negative, only concerned himself with the development of the medium because he found his drawings of the banks of Lake Como too amateurish. With the help of photography we are able to reproduce the world around us at the touch of a button, with unparalleled realism. Early travel photography acquainted people with countries, and the inhabitants of countries, they never visited themselves. Today it seems as if every corner of the world has been photographed from every conceivable perspective. Travel photography snowballed along with the explosive development of tourism

Particularly in foreign countries you should always ask permission before you take somebody's photograph.

and now there are hardly any holiday-makers who go away without taking along a camera.

Holiday photographs don't just capture your own experiences in pictures, they encourage people to travel more. The many colourful books of the natural beauties of this world, of the fascinating buildings of strange cultures and people from exotic countries have turned the desire to travel into an important economic factor. Holiday-makers are tempted with many colourful brochures. Magazines stimulate our wanderlust with images of our world in the most beautiful colours. It all seems as if there is nothing on this earth that hasn't fallen victim to photographers' enthusiasm a hundred times over. And despite the many brilliant photographs, some by excellent photographers, travellers continue to reach for their own cameras in order to capture the moments of their very own personal

experiences on film. Translating personal experiences into pictures is the secret which decides whether a photograph fascinates or bores its viewers. If you don't manage to capture on film what is special about your personal experiences you won't take good photographs home with you, only colourful pictures to help your own memories. The Leaning Tower of Pisa, the Grand Canyon, Niagara Falls and the Pyramids have been photographed countless times, much better than you will ever be able to do it yourself. But a good private travel photograph can still convey a fascinating message, both in artistic terms and in terms of content. Individual experiences turn personal holiday photographs into valuable documentation for the traveller themselves, as well as for the onlooker.

As long as you're reproducing landscapes and buildings you won't meet any particular problems. The things to watch out for are described in the section giving tips on architectural and landscape photography. What causes problems when photographing abroad is the different culture of the country being visited, the customs and habits of people, all of which the photographer will want to document in pictures.

Every travel photographer should realize that the search for unusual subjects should have its limits, dictated by respect for the feelings of the people of different countries. Quickly snapping photogenic people without their permission is a bad habit that is becoming increasingly widespread amongst tourists and it's no wonder if such angry 'photo victims' suddenly start throwing stones. It should be a matter of course for every photographer to ask permission if they want to take somebody's picture, whether abroad or not. But this means taking the time to talk to those people, possibly taking away their fear of the camera in this way. If you run around armed with a camera, to collect photographs of places that have already been photographed countless times, you'll only end up with a good shot by accident. If you want to dig more deeply, spend time finding out about the country you're visiting and its people beforehand. When you finally get there, take the time to talk to people. Most people like being photographed if you ask them nicely.

One reason why many photographers still continue to use telephoto lenses to take sneaky photographs of strange people is a fear that their subjects might lose their natural attitude and start

posing as soon as the camera is noticed. But if you do spend some time with people, their inhibitions will usually soon disappear and that natural smile will return. So if you want to get good portraits it pays to have a lot of time, patience and above all, tact and sensitivity. Such pictures will show whether somebody is really interested in a country and its people or whether they are simply a photographic souvenir hunter.

The attraction of travel photography is the mixture of every conceivable subject area from landscapes, buildings, people and festivals, as well as detail shots at very close range. So the travel photographer needs to be prepared for every eventuality. He needs to anticipate what sort of subjects he will come across, but must still be prepared for the unexpected, and be able to respond spontaneously. Equipment, therefore, must be as versatile as possible, yet still be easy to carry. It's not everybody's cup of tea to put up with the sort of inconvenience early travel photographers had, just to capture souvenir holiday shots. But with the compact Minolta 3xi or SPxi this is no longer necessary. They allow you to master most photographic tasks on holiday comfortably. The integral flash unit of the 3xi in particular, makes hot-shoe mounted flashguns mostly superfluous and this is not only useful for shots on the move in badly lit rooms. It can also provide effective foreground lighting at twilight.

One useful accessory no travel photographer should be without is a polarizing filter to eliminate reflections on non-metallic surfaces. By eliminating reflections, substantially richer colours results, the sky looks a deeper blue and the clouds become whiter. Green fields and trees will also look more intense.

Experience proves that it is advisable to buy your film at home before you leave. When you're on the move it's often impossible to find the film type you're used to while at home you know the dealer and know how the material is stored. In hot countries films that have been stored for too long are likely to have got colour casts.

A spare battery is even more important than sufficient film, because once the lithium battery is used up, both cameras will seize up. Not only are lithium batteries still extremely expensive in some countries, they may also be very difficult to get hold of.

Different countries have different customs, and something that's permitted at home may not be allowed somewhere else. You should remember this before you take a nude photograph of your wife or

146

Zoom lenses with longer focal lengths are particularly useful in situations where you can't get in as close to the subject as you want.

girlfriend on the beach, for example. Find out before you leave home what's permitted and what isn't. In some countries even photographing a train platform without permission can be enough to get you in trouble with the authorities. In other countries it's prohibited to photograph airports, harbours or bridges, and many people refuse to be photographed for religious reasons.

## How to take impressive holiday photographs

* Keep your equipment to a minimum, so that you'll take it with you rather than leave it in the hotel out of sheer laziness
* Photograph your own personal experiences, don't try to imitate postcard shots
* Discover your subject with the camera, photograph it from different angles and positions
* Get close to your subject and show details
* Ask the permission of the person you want to photograph first and then take your time
* Use early morning and evening light
* Find out about any restrictions on photography before you leave

## Equipment

### Lenses
Minolta AF Zoom xi 28-80mm,f/3.5-4.5 or
Minolta AF Power Zoom 35-80,f/4-5.6 and/or
Minolta AF Zoom xi 35-200mm,f/4.5-5.6

### Accessories
Minolta 2000xi program flash unit (for SPxi)
or Minolta 3500xi program flash unit
Minolta mini tripod
Polarizing filter

# Tips for better landscape shots

Landscape photography has a long tradition and is still one of the most popular areas of amateur and professional photography. The constantly changing image of our earth has been captured in millions of shots. We can see the change in our environment in old and new pictures, welcoming or regretting this change. Although many famous landscapes have already been photographed thousands of times, no two pictures are the same. Landscape shots can only be repeated to a certain extent, for landscape - a piece of living nature - is constantly changing. We don't just experience great change with the change of the seasons. Sun, clouds, wind and weather aren't the only factors which influence the face of nature. Landscapes literally show a different side of themselves from hour to hour. Landscape photography, someone once said, is meteorology in practice.

The worst time for landscape shots is around midday on a sunny day. As the sun is very high in the sky and as the shadows are short, almost imperceptible, the landscape loses its depth. Mountains, trees and buildings appear flat and boring. A slight haze usually masks the view into the distance.

When the sun is lower down in the sky, on the other hand, the shadows become longer, objects in the landscape suddenly appear much more three-dimensional. The play of light and shade adds drama and tension to the photograph. Sunshine immediately following rain is also excellent for landscape shots with the air clear, colours glowing, and the wetness adding a fresh shine to everything.

Although landscape shots can't be repeated, their effect can be anticipated to some extent. The photographer needs to study the change in a landscape at different times of the day. He needs to know which cloud and weather pattern is most suitable for his subject. He has to take his time with his shots, occasionally even risking a fruitless trip when the light wasn't quite right. As landscape photography isn't necessarily quick and hectic, the photographer can mount the camera on a tripod and take his time composing the shot.

One common mistake with landscape shots is a grey-blue sky taking up the majority of the shot, causing nothing but yawns all

Close: Photographing a landscape with a long focal length directs the eye to the essentials.

round. Small white fleecy clouds can be a lot more interesting in a sky than monochrome blue but dramatic cloud patterns usually add extra impact to your landscape. And although sunshine is usually good for landscape shots, shots in hazy conditions, fog, snow or rain can also achieve fascinating results.

On the other hand, snowy landscapes without sunshine and under an overcast sky mostly look grey and lifeless because the diffused light takes all the contours out of the landscape. For shots at twilight, on the other hand, an overcast sky can provide good light where the snow will then look cold and blue, maybe contrasting the warm yellow light diffusing from the windows of houses.

The horizon plays a very important role in landscape photography and all too often photographers don't even make sure it runs through the shot horizontally. Many beginners automatically

Distant: Landscape shots with a wide-angle lens emphasise the foreground.

place it in the centre of the shot but this mostly leads to dull photographs except in certain circumstances. Blue sky taking up half of a shot also looks boring, although a seagull or a flock of birds can help make such a 'sky-heavy' shot more interesting. In most cases, dividing the shot into one-third sky and two-thirds landscape adds more suspense to the photograph than a simple symmetrical division.

With landscape shots, too, the framing is particularly important because, after all, such shots are supposed to convey an overview. Although many photographers tend to reach for wide-angle lenses to take landscape shots, short telephoto focal lengths can also be used effectively and have several advantages. First, tighter framing allows you to leave out unwanted areas of the subject and second, a telephoto lens concentrates perspective. This means that it

compresses details placed at different positions through the depth of the shot.

Wide-angle shots, on the other hand, emphasize the impression of depth. The foreground takes up a relatively large proportion of the scene, and distant objects appear small. The great variety of detail in landscapes, and their great spatial extension, demand great depth of field, which can be achieved by using narrow apertures and films that render details as brilliantly as possible. Photographers for a magazine like *National Geographic* consider Kodachrome 25 as the ultimate film material. But because of the long processing turnaround time many photographers have switched to Ektachrome material that can be developed within 90 minutes by a specialist lab. The Ektachrome HC 50 or the warmer Ektachrome 64X are favourites among professional circles. Another reason for this is the fact that these films are excellent for reproduction in print.

---

### How to take magnificent landscape shots

* Use the early morning and evening light
* Use a tripod
* Watch out for the horizon
* Use aperture priority mode with narrow aperture for great depth of field
* Use a polarizing filter
* Use films of the slowest possible speed

### Equipment

**Lenses**
Minolta AF Zoom xi 28-105mm,f/3.5-4.5 and
Minolta AF Zoom xi 100-300mm,f/4.5-5.6 or
Minolta AF Zoom xi 35-200mm,f/4.5-5.6

**Accessories**
Minolta 3500xi program flash unit
Tripod
Circular polarizing filter

---

# Tips for better close-ups

Small things greatly enlarged often make particularly attractive subjects. Things that escape a fleeting glance are only made truly visible by the camera, so an excursion into the world of macro photography can turn into something of an adventure. Close-up shots are worthwhile in almost all subject areas. In travel photography, shots of architectural details, of traditional embroidery or of the exotic flora of a country can make fascinating as well as informative photographs. In animal photography, the hunt for small animals, beetles and insects represents a genre within a genre. In documentary or sports photography, too, close-up shots can guide the eye to the many details that have a decisive influence on events. A close-up shot of the chalk-whitened hands of a gymnast, the spikes on a sprinter's shoe, or a rifleman's finger on the trigger - all these can produce photographs that say more about an event than a standard shot.

The new Minolta zoom lenses allow very short shooting distances, and hence large reproduction ratios. With the Minolta AF Zoom xi 80-200mm,f/4.5-5.6 Macro the photographer can get as close as 1.5 metres to his subject, achieving a maximum reproduction ratio of almost 1:4.

The maximum reproduction ratio of a lens indicates the maximum ratio between actual subject's size and its image on film. So at a reproduction ratio of 1:4, the subject is therefore reproduced at one-quarter of its actual size on the film. At a reproduction ratio of 1:2 an object appears at half its size, and at a reproduction ratio of 1:1 at its actual size.

Normal lenses are not suitable for the extreme close-up range, with reproduction ratios greater than 1:4 but there are a number of accessories which can extend the maximum reproduction ratio possible with a lens.

The easiest method is to use lens attachments, available from many manufacturers, which are simply screwed into the filter thread of the lens. They reduce the minimum shooting distance and therefore achieve greater reproduction ratios. They are available with different strengths and several of these lens attachments can be used together. Minolta supplies achromatic attachments in three strengths, for filter diameters of 49mm and 55mm and their

strength is given in dioptres. Using lens attachments does not affect the autofocus or the exposure metering system, but their scope is limited.

It is better to reduce the closest focusing distance by increasing the length of the lens by means of bellows units, although you have to do without the automatic focusing function. Bellows units with Minolta bayonets are available from Novoflex, a specialist supplier of close-up accessories.

But the simplest way to achieve close-up shots is by using a macro lens designed to work over short shooting distances with long barrel extension. Two macro lenses are available for the 3xi and SPxi, namely the Minolta AF 50mm,f/2.8 Macro and the 100mm,f/2.8. Both lenses allow you to shoot at life size, up to a reproduction ratio of 1:1, without the need for close-up accessories. These lenses not only deliver excellent performance at close range, but also at greater distances.

Whilst the longer focal length is more suitable for shots of small animals, where you have to keep at a certain distance so they don't run away, the 50mm standard focal length lens is better suited for copying. Here short distances between subject and front element are necessary to avoid over-large copying stands. The 50mm macro lens is also well suited for close-up shots of flowers and plants, as well as small objects, provided you don't need much space between the front element and the subject to squeeze in lighting equipment.

One ever-present problem with close-up photography is the depth of field. It decreases rapidly as the reproduction ratio in-

---

*Medium telephoto focal lengths are particularly good for shots of buildings, without distortion or converging verticals. Photo: R. Hagenauer*

creases. Another factor is the aperture, and the wider this is, the narrower the sharp zone either side of the point of focus becomes. This is why the camera should be set to aperture priority mode, with as narrow an aperture as possible.

Large reproduction ratios also increase the danger of camera shake, so it is advisable to use a tripod or a very fast shutter speed for close-up shots whenever possible. But narrow apertures giving great depth of field, combined with fast shutter speeds to reduce the danger of camera shake, require plenty of light. As the graininess of high-speed film means that they are not an acceptable option for close-up shots, where detail is important, you need to use flash light in most cases.

The Minolta Macro Flash 1200AF Set N can help in these situations. The Macro Flash has four flash tubes which can either be fired together for shadow-free illumination, or separately to provide a more three-dimensional effect. The flash head of the ring flash unit is screwed onto the lens like a filter and the generator is mounted on the hotshoe of the 3xi or SPxi with the Flash Shoe Adapter FS-1100.

*The wide variety of possible subjects means that zoom lenses with their variable focal lengths are an indispensable tool for travel photographers. Photo: R. Hagenauer*

## How to take impressive close-up shots

\* Because of the shallow depth of field, always shoot small subjects from the angle where they have the least depth

\* Use flash, or preselect a narrow aperture in aperture priority mode

\* Mount the camera on a tripod if possible and photograph with self-timer

### Equipment

**Lenses**
Minolta AF 50mm,f/2.8 Macro or
Minolta AF 100mm,f/2.8 Macro

**Accessories**
Minolta Macro Flash 1200AF Set N
Flash Shoe Adapter FS-1100
Tripod
Copy Stand II

## Tips for better architectural shots

Nowhere is human creativity more convincingly and solidly represented than in fascinating buildings and monuments from different epochs. These impressive witnesses to human creativity are amongst the most popular subjects of amateur photographers. But it is often difficult to capture buildings in pictures, because their surroundings prevent the photographer from shooting from the required distance. Wide-angle lenses are needed in order to be able to photograph large buildings at close range and the shorter the focal length of a lens, the shorter the possible shooting distance.

Having a person in the shot is usually the best way of showing the relative sizes of things in a photograph.

But apart from the distance of the subject, the height of a building also plays a decisive role. The optimum shooting position for shots of buildings is at roughly half their height. But usually the photographer will have both feet on the ground, with the building towering above them. To squeeze it all on film, you need to tilt the camera upwards, but the more the camera is tilted, the more unnatural the result usually looks. On the photograph the building will look as if it were falling over backwards. This effect, called converging verticals in photographic jargon, occurs whenever the back cover of the camera and the vertical lines of the subject don't run in parallel. In other words, whenever the camera is tilted.

This tilting of the camera can be avoided by selecting a raised shooting position. This is possible, for example, when you are able to take your shots from the upper windows of the building opposite.

But even if the wide-angle lens is sufficient to capture all of the building with the camera held straight, low shooting positions hold

a further disadvantage. As the optical axis is parallel with the ground only at eye-level, it will take up almost as much space in the shot as the building itself. Unless you're dealing with a particularly interesting forecourt with attractive paving, this unbalanced relationship between main subject and foreground is usually unattractive. If you're shooting with negative film, you can salvage such shots in the darkroom by printing sectional enlargements to compensate for the perspective. With slides, sectional duplicates are not only expensive, but usually mean a substantial loss in quality.

Careful picture composition - the division of vertical and horizontal lines, of shapes and structures - adds the special touch to a successful architectural shot. Many architectural photographers therefore use a tripod. It doesn't just guarantee shake-free shots with long shutter speeds and narrow apertures, it also allows you to check your framing precisely and without hurrying.

With most buildings, the beauty of their architecture is only fully revealed in the play of light and shadows, maybe when the sun is low in the early morning or evening. The shadowless light of the midday sun directly overhead, on the other hand, will probably only produce interesting shots of buildings with a lot of cornicing and distinctive ledges or bays.

As the reduced brightness in the morning and evening requires faster shutter speeds, a tripod is a useful help to prevent camera shake at small apertures. But recording the structures and lines that lend special character to a building can only be achieved with a fine grain, low speed film.

An overcast, grey sky and diffuse, soft light are not very suitable for architectural shots. A whole series of photographs of a building taken at different times of day or even different times of year can show interesting changes. Shots taken at intervals over several years can produce documentaries of great value but the longer the intervals between separate shots, the more important it is that the photographer makes accurate notes of the shooting position and focal length. The aperture, too, can play an important role in terms of the depth of field of such shots. You should therefore shoot from a tripod, in aperture priority mode and always with the same aperture, in order to get identical framing with a constant spatial effect.

Buildings lit up at night can be fascinating. They can be given extra zest by changing the focal length during the exposure. In this

case, you have to work in manual mode, to be able to set a sufficiently narrow aperture for the long exposure.

Remember that the wide spectrum of architectural photography doesn't just include overview shots. Often it's the small details of a building that reveal the great skill of the architect and master builder.

Souvenir shots of people in front of famous buildings are almost a must for every traveller. But many photographers make the mistake of placing their subject directly in front of the building where they'll be dwarfed by the huge building. Here the photographer should use the laws of perspective to advantage. As objects at different distances from the shooting position appear at different sizes on film you should compose the shot so that the monument fills the frame in the background, and the person is positioned close to the camera. Make sure that the person doesn't cover up important parts of the building and also preselect an aperture that guarantees sufficient depth of field, to keep both person and building in focus. It can often be helpful to set the focus plane manually, slightly behind the person. This is because about one-third of the depth of field in the shot will extend forward from the setting plane, two-thirds behind it.

Interior shots are also part of architectural photography. In large rooms - the nave of a church for example, a theatre or the great hall of a castle - you often have to do without flash, partly because of its limited range and partly because its use is not permitted. In this case you need to use fast films, such as the Kodak Ektar 1000, which delivers remarkable sharpness and reproduction of detail, despite its high speed. Otherwise, bolt your camera to a tripod.

If you need to use flash, why not get yourself a slave flash? Such auxiliary flash units, fired by remote control from the camera flash unit via a photo diode, are available from various manufacturers and are relatively inexpensive. The flash can simply be set up in a room so that they illuminate areas of the subject that the integral flash unit of the 3xi won't reach. Using the integral flash unit in conjunction with the remotely controlled 3500xi program flash unit is also a good way of lighting large rooms.

## How to take impressive architectural shots

* Don't tilt the camera
* With tall buildings, select a raised shooting position to avoid intrusive foregrounds
* Use morning and evening light
* Use a tripod
* Don't position people directly in front of a building but closer to the camera
* Use slave flash units to light larger rooms

## Equipment

### Lenses
Minolta AF Zoom 24-50mm,f/4
Minolta AF Zoom xi 28-80mm,f/4.5-5.6
Minolta AF Zoom xi 28-105mm,f3.5-4.5

### Accessories
Tripod
Polarizing filter
Slave flash unit
Minolta 3500xi program flash unit

# Filters and other Lens Attachments

Minolta offers ten different types of filters for black-and-white and colour photography for the Maxxum/Dynax system. There are filters for colour that suppress colour casts and improve colour saturation. There are also neutral filters to absorb UV radiation, and special filters for black-and-white photography. Working with filters requires the photographer to know certain basic rules about their handling and effect and this knowledge is best acquired by carrying out your own tests and experiments. Further attachments for Minolta AF and xi lenses are achromatic close-up lenses which decrease the close-up distance, and then there's the underestimated lens hood.

**UV Filter** - Film emulsions used to react strongly to UV radiation giving heavy blue casts and a loss in sharpness. Strong UV radiation is often found in mountains and by the sea but nowadays modern films often include a layer that blocks UV radiation, making such filters superfluous. However, UV-absorbing filters are completely colourless and absorb no light, so they do not influence the exposure in any way, and they are often kept on the lens to protect the front element.

**Skylight Filter 1B/1A** - These filters produce a slightly warmer colour rendering. They suppress blue with subjects shot in so-called open shade without direct sunlight, where the blue of the sky is reflected and give warmer colours in dull and hazy conditions. The 1B filter has a slightly stronger effect than the 1A.

**Conversion filters** - These filters let you match the colour sensitivity of colour film to the colour temperature of the illumination. Filter type B12 (blue) is used to suppress the red bias you get when using daylight film in tungsten light. Filter R12 (red) is used when a tungsten film is used in daylight where a heavy blue cast is suppressed.

Lenses with focal lengths above 100mm are particularly suitable for portraits of children.

**Polarizing filters** - These help to remove unwanted reflections from non-metallic surfaces. A shot taken with a polarizing filter usually has stronger colours and the sky is a deeper blue. The effect of the filter can be varied by turning it but the strongest effect on a blue sky occurs when the shooting direction is 90° to the direction of the sun's rays.

There is one problem when using polarizing filters on an AF lens. The front barrel of some lenses rotate during focusing, which means that the polarizing filter is turned as well. Consequently the filter has to be adjusted after correct focus has been set and it may be simpler to change to manual focusing when using a polarizing

filter. Alternatively, a filter holder enables the front element to move freely.

The autofocus system and the exposure metering of the Minolta Maxxum/Dynax cameras will only allow circular polarizing filters to be used. Linear polarizing filters affect the AF and exposure metering of the camera and are not recommended.

**Neutral density filter ND-4X** - These special filters are neutral grey and do not affect colour rendering. They are used in colour and black-and-white photography if the light is too bright, or to let you use large apertures or slower shutter speeds in bright conditions to achieve special effects.

**Filters for black-and-white photography** - Minolta offers four filters of this type - yellow, green, orange and red. Yellow improves the reproduction of blue sky and clouds. Green also darkens blue sky and lightens the greens of grass and foliage. Orange is often used for landscapes, producing dark dramatic skies.

Red filters have a similar but even more intense effect and blue sky appears very dark. Red filters are also used for infrared photography. The high density of some red filters could affect the AF system of the camera but you should experience no problem with the Minolta R60 filter. Since all colour filters absorb light to varying degrees, the exposure must be increased to compensate but this is automatically taken into account by TTL exposure control.

**Gelatin filter holders** - Kodak offers 7.5x7.5cm light-balancing filters. These adjust the colour temperature of the illumination to match the colour sensitivity of the film emulsion and are clamped in special Minolta filter holders, which you screw into the filter thread of the lens.

**Minolta Portrayer filters** - As the word 'Portrayer' may already suggest, these are soft-focus effect filters used for portrait photography. Minolta offers two types giving different effects.

S1 and S2, supplied as a set, are intended for general soft-focus photography with lenses of focal lengths between 50mm and 210mm. P1, P2, and P3, also available as a set, are for particularly

flattering portraits where a special softening effect on skin tones is wanted. They are distinct from other filters of this type because the aperture does not influence the softening effect although the focal length of the lens plays an important role. The soft-focus effect increases with increasing focal length. This makes these filters particularly useful in program mode, when the aperture cannot be controlled manually. If a strong soft-focus effect is desired, more than one filter can be used. All Portrayer filters keep the centre in sharp focus with the soft-focus effect increasing towards the edge of the frame.

**Achromatic close-up lenses** - These are used to decrease the closest focusing distance and thereby increase the reproduction ratio. The Minolta type consist of two cemented elements which are screwed into the filter thread of the lens. Compared with simple close-up lenses, achromatic lenses give a much better quality of reproduction. At f/8 and smaller, reproduction quality is very acceptable - larger apertures are not recommended.

Minolta offers three lenses with different magnification which can be combined to obtain different reproduction ratios. Always attach the close-up lens with the smaller number first. Although the autofocus system is not adversely affected by using these attachments it is important to stay within the restricted distance range where focusing is still possible.

They are available in 49mm and 55mm filter thread sizes. They are identified as 0 for +0.94 dioptres, 1 for +2.0 dioptres and 2 for +3.8 dioptres.

**Lens hood** - This is a very useful and almost indispensable accessory. With some Minolta lenses the hood is already built-in, but others come supplied with a separate clip-on or bayonet-fitting hood. They prevent light entering the lens from an oblique angle, which can refract and scatter inside the lens giving poor contrast and an impression of unsharpness. Lens hoods are another way of ensuring good quality pictures and are a simple, relatively cheap and often underestimated accessory.

**Eyepiece Corrector 1000** - Although the 3xi and SPxi set the focus automatically, photographers who wear spectacles often

have problems assessing the picture through the viewfinder. For this reason Minolta offer nine eyepiece correction lenses with values between -4 and +3 dioptres for the Maxxum/Dynax cameras. These lenses simply snap onto the camera's eyepiece.

The appeal of this shot lies in the unusual balance of the composition.
Photo: R. Hagenauer

# Flash accessories

**Cable CD** - The four-pole sockets at either end of this cable allow the connection of a second 5200i flash unit or the Off Camera Shoe OS-1100 to use two flash units for studio-quality flash illumination. The 5200i program flash unit does not need to be mounted on the camera but can be controlled via the Off Camera Cable OC-1100 and the Off Camera Shoe OS-1100. The EX extension cable is also available for off-camera flash work. A maximum of five EX cables can be connected together to extend the Off Camera Cable OC-1100 or the Cable CD.

The remote control cables
RC-1000L and RC-1000S

In conjunction with the Off Camera Cable OC-1100 and the Triple Connector TC-1000, TTL control of up to three flash units (2000i, 2000xi, 3200i, 3500xi or 5200i) is possible. If a 5200i is mounted on the camera, Cable CD is sufficient to control the three flash units via the automatic flash control system.

**Off Camera Cable OC-1100** - This spiral cable can be pulled to a length of about one metre and can, if necessary, be extended with five EX cables.

168

It allows more flexible lighting with the Minolta program flash units. The OC-1100 can be connected directly to the accessory shoe on the side of the 5200i program flash unit. For other Minolta program flash units, the Off Camera Shoe OS-1100 is required.

**Off Camera Shoe OS-1100** - This flash contact shoe for four-pole plugs with clip-on shoe and tripod thread allows a connection between program flash units and Maxxum/Dynax cameras, via Off camera Cable OC-1100.

**Triple Connector TC-1000** - This distributor with a four-pole plug for OC-1100 or CD cables and three four-pole couplings for Cable EX is used to connect up to three flash units to Maxxum/Dynax cameras simultaneously.

**Flash Shoe Adapter FS-1100** - This allows the use of 1000 series flash units - such as the 1800AF, 2800AF and 4000AF - with i and xi series cameras.

**Bounce Reflector III and IV Set** - These light, collapsible reflectors provide soft and indirect flash lighting everywhere, even outside. The Bounce Reflector III Set can be attached to the 5200i program flash unit, the Bounce Reflector IV fits the 3500xi program flash unit.

**Ni-Cd Charger NC-2 and External Battery Pack EP-1 Set** - If flash is used a lot, and special functions like strobe flash are used frequently, it is advisable to use rechargeable Ni-Cd batteries instead of expensive standard batteries. Additionally, the external battery pack reduces the recycling times for the Minolta 5200i program flash unit and increases the number of flashes possible.

## Slide Copy Unit 1000 and Macro Stand 1000

Minolta offers two accessories specially designed for the production of high-quality duplicates or copies. The Slide Copier 1000 and the Macro Stand 1000 can be used on all Maxxum/Dynax AF SLR cameras in conjunction with the AF 50mm,f/2.8 Macro, the AF 100mm,f/2.8 Macro and the AF Macro Zoom 3X-1X.

**Slide Copy Unit 1000** - This useful and practical device has a 35mm slide holder set above an opaque perspex screen which ensures that the slides are evenly lit. The original slide can be moved inside this holder easily, yet very precisely, by turning setting knobs to adjust its vertical and horizontal position until you achieve optimum framing. The slide copier is mounted on a special stand designed so that the flash reflector of the Macro Flash 1200AF can be attached quickly and easily.

This special macro flash unit is an excellent light source for evenly lighting original slides. The Slide Copy Unit 1000 can be used in conjunction with the tripod of the AF Macro Zoom 3X-1X,f/ 1.7-2.8 when this lens is used.

**Macro Stand 1000** - The Macro Stand 1000 is a practical, easily operated accessory for macro shots with the Minolta AF 50mm,f/ 2.8 Macro and the AF 100mm,f/2.8 Macro. The tripod socket of the camera body is connected to the adjustable arm of the rigid tube. The baseboard with its integral transparent subject table allows the subject to be carefully positioned before being photographed. Used in conjunction with the Slide Copy Unit 1000, this device allows fast and easy shooting at a reproduction ratio of 1:1.

The macro stand and slide copy unit allow easy slide duplication with the 3xi or SPxi in conjunction with a suitable macro lens.

# Storing and caring for your camera

Minolta cameras are valuable precision tools, crammed full of the most modern electronics and precision engineering. You should always handle them with care. Whilst the high-quality plastic body can cope with the odd rough blow, shocks, high humidity and dirt can affect the functioning of the camera. So you should always protect your camera against such environmental factors. A lens hood is a good protection for the front element of the lens since it makes fingerprints and scratches less likely, and it can improve optical quality. When the camera is not used, you should always put on a lens cap.

Strong heat and high humidity are the enemies of every electronic system, so your camera should be stored in a dry place and at normal temperatures. The glove compartment or boot of a car parked in glaring sunshine are just about the most unsuitable places.

Certain fumes and chemicals can also damage the camera body and its electronic system, and you must never oil or grease any camera component. The same does, of course, apply to lenses. The shutter curtains of the camera are particularly sensitive, and you should always be careful not to touch them when loading a film.

Compressed air is unsuitable for cleaning precision instruments such as modern cameras. It swirls the dust around rather than blowing it away, and the stream of air directed into the interior of the camera could change some of the settings inside the camera. A fine dust brush is still the safest cleaning tool and a dry, soft cotton cloth, possibly impregnated with silicon, is best way to clean the exterior of the camera and lens.

But never use a silicon cloth for cleaning the glass surfaces, which are best treated with the dust brush. If necessary you may need to get the special lens cleaning tissues or cloths from photo dealers. If the lens glass surfaces or the viewfinder eyepiece are heavily soiled, you may need to use a liquid lens cleaner. Such cleaners must be applied to the cleaning cloth sparingly, they must

never be applied directly to the glass surface. If soiling is very heavy, it is advisable to have the camera cleaned by an authorized Minolta service agent.

If you want to store the camera for a longer period of time, you should rewind and remove any film still in the camera and then take out the battery. The camera is best stored in an airtight container, together with some silica gel to absorb any humidity. Silica gel is available from pharmacies and damp silica gel can be dried in the oven and re-used. This absorbent material is particularly indispensable for longer periods in humid climatic zones, like the tropics.

However, an airtight camera case can prove problematic in such situations. If its interior cannot be kept completely dry, it will develop a climatic zone of its own, encouraging the formation of fungus on glass surfaces. Experience has shown that a cotton bag, which lets air get in and out, is a better way of storing the camera as it absorbs as well as gives off humidity.

When the camera is to be used after a long period of time, check all camera and lens functions before taking any important shots. This will help you become familiar with the camera again, and will prevent any disappointment over spoilt shots.

The liquid crystal display of the data panel will normally function at temperatures between -20° and +50° Celsius. Beyond this minimum the contrast and speed of the displays will change, and the data may become difficult to read. At particularly high temperatures the data panel may temporarily go black so that the displays are invisible. But the displays will recover at normal temperatures and will again function perfectly.

If the camera malfunctions you must never attempt to repair it yourself. Instead, you should either send it to the nearest Minolta service agent or take it to a Minolta dealer. It is a good idea to keep the original packaging of the camera, so that it can be packed securely for dispatch. To save unnecessary expense, you should telephone the nearest Minolta service agent before posting the camera because the camera may just have locked because of an operating error, and often you can get it going again by simply removing and re-inserting the battery. For example, electronic circuits can switch themselves off, even though a battery with sufficient capacity is in the camera. In such cases you may only need to take out the battery and put it back again for the camera to

resume normal operation. Minolta recommends that the camera should be cleaned and checked annually by an authorized Minolta service agent, especially if it is used frequently.

**Minolta Camera Co., Ltd.,**
3-13, 2-Chome, Azuchi-Machi, Chuo-Ku, Osaka 541, Japan

**Minolta GmbH**
Kurt-Fischer-Strasse 50, D-2070 Ahrensburg, Germany

**Minolta France S.A.**
365-367 Route de Saint-Germain, 78420 Carrieres-Sur-Seine, France

**Minolta (UK) Limited**
103 Tanners Drive, Blakelands North, Milton Keynes, MK14 5BU,
England

**Minolta Austria Gesellschaft m.b.H.**
Amalienstrasse 59-61, 1131 Wien, Austria

**Minolta Camera Benelux B.V.**
Zonnebaan 39, 3606 CH Maarssenbroek, P.B. 264, 3600 AG
Maarssen, The Netherlands

**Belgium Branch**
Stenen Brug 115-117, 2200 Antwerpen, Belgium

**Minolta (Schweiz) AG**
Riedhof V, Riedstrasse 6 8953 Dietikon-Zurich, Switzerland

**Minolta Corporation**

**Head Office**
101 Williams Drive, Ramsey, New Jersey 07446, U.S.A.

**Los Angeles Branch**
11150 Hope Street Cypress, CA 90630, U.S.A.

**Chicago Branch**
3000 Tollview Drive, Rolling Meadows, IL 60008, U.S.A.

**Atlanta Branch**
5904 Peachtree Corners East, Norcross, GA 30071, U.S.A.

**Minolta Canada Inc.**

**Head Office**
369 Britannia Road East, Mississauga, Ontario L4Z, 2H5, Canada

**Montreal Branch**
3405 Thimens Blvd, St. Laurent, Quebec H4R 1V5, Canada

**Vancouver Branch**
105-3830 Jacombs Road, Richmond, B.C. V6V 1Y6, Canada

**Minolta Hong Kong Limited**
Room 208, 2/F, Eastern Center, 1065 King's Road, Quarry Bay, Hong Kong

**Minolta Singapore (Pte) Ltd.**
10, Teban Gardens Crescent, Singapore 2260

**NOTES:**